EDGE OF THE SUBLIME

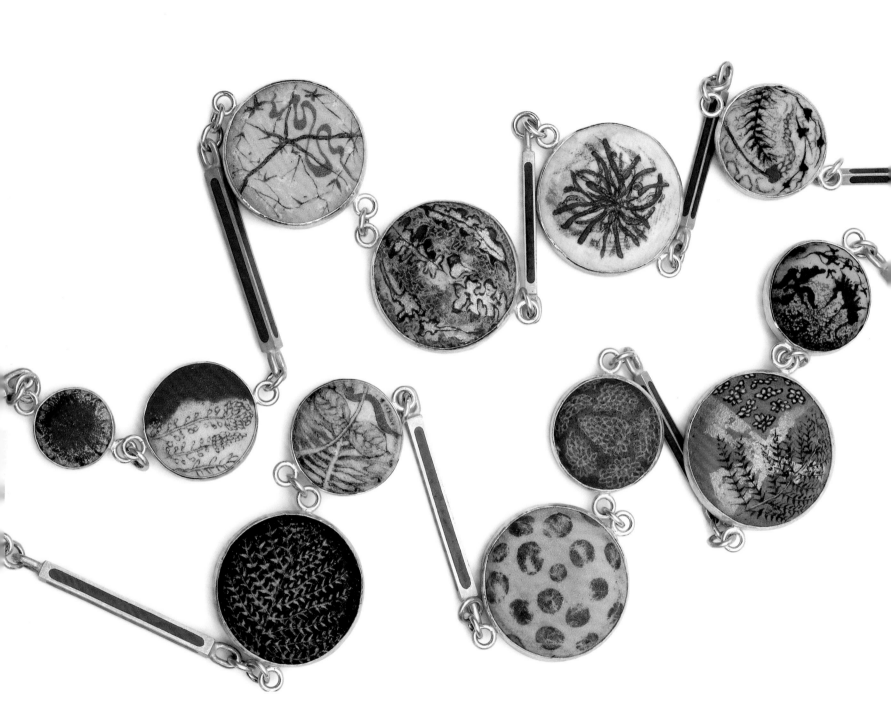

EDGE OF THE SUBLIME
Enamels by Jamie Bennett

JEANNINE FALINO

with essays by

Patricia C. Phillips

Karl Emil Willers

FULLER CRAFT MUSEUM
HUDSON HILLS PRESS
NEW YORK AND MANCHESTER

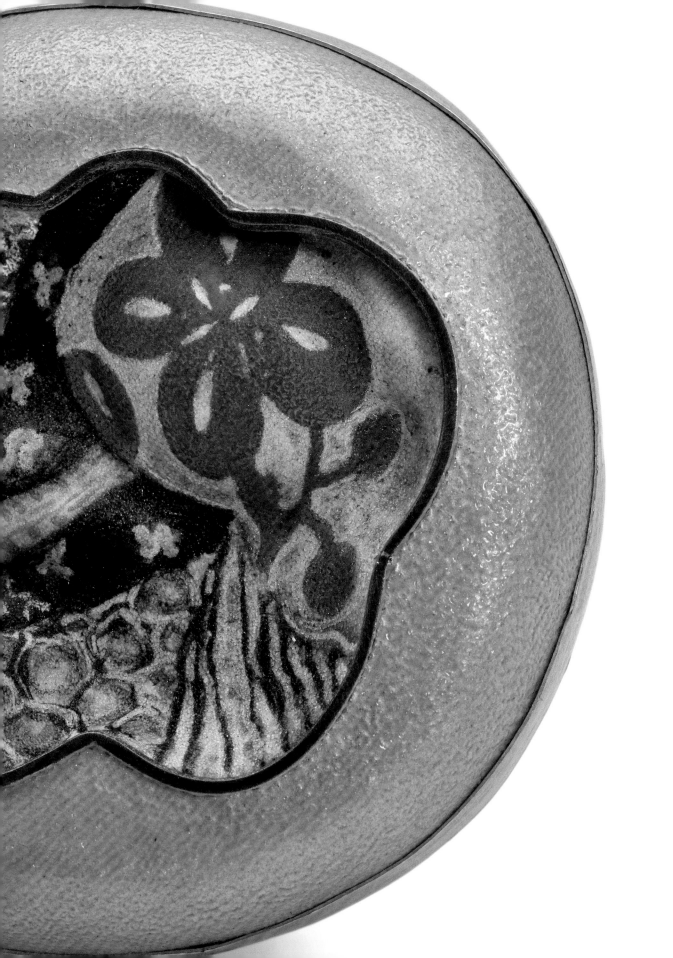

Contents

Foreword 7
 Gretchen Keyworth

Acknowledgments 9

The Contemplative Jeweler 11
 Jeannine Falino

Lost & Found: Meaning & Memory 25
 Patricia C. Phillips

Drawing Out Ideas 37
 Karl Emil Willers

PLATES
 Jewelry 45
 Wall Reliefs 101
 Paintings & Drawings 111

Checklist of the Exhibition 126

Appointments, Fellowships, Artist Residencies, Selected Lectures 135

Selected Exhibitions 136

Public and Corporate Collections 138

Selected Bibliography 139

Index 141

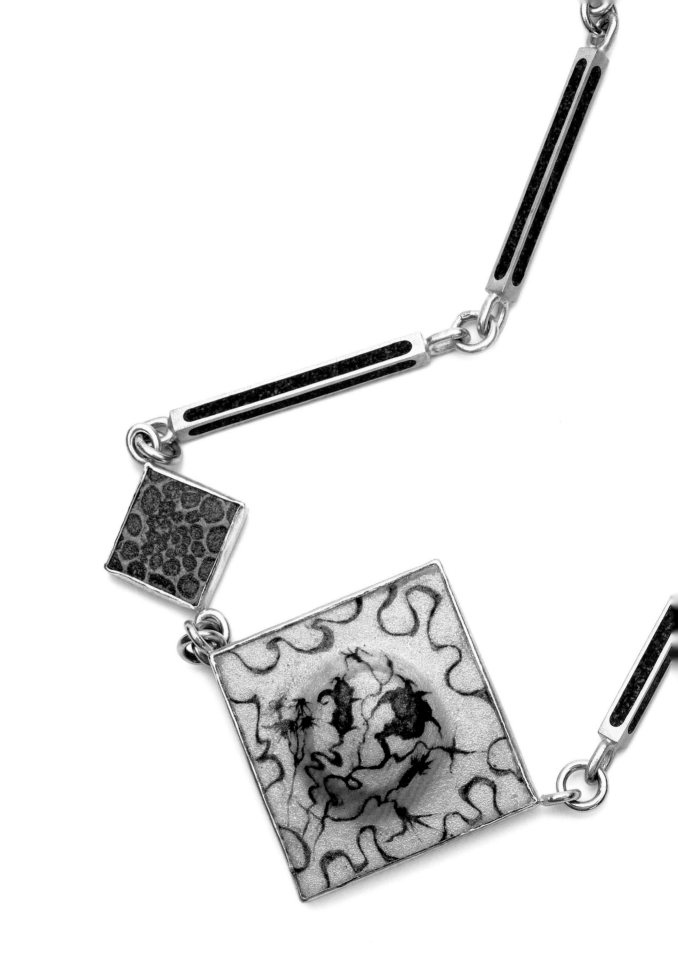

Foreword

I have known Jamie Bennett for many years and have watched with pleasure as his multifaceted career has grown and matured. When Fuller Craft Museum was invited to sponsor a retrospective exhibition for Jamie, it was clear that the time had come for this remarkable artist to be featured in a museum exhibition. Indeed, it is an honor to present his jewelry, wall sculptures, drawings, and paintings to the public.

Such an undertaking is, however, never the product of a few individuals or a single institution. From the moment this project began, grant writers and foundations, curators and writers, exhibition planners and preparators came forward to guarantee that this retrospective would be well planned and funded.

For their vision and support, without which the exhibition and this catalogue would have been impossible, I would like to thank the Windgate Charitable Foundation's Artist's Exhibition Series and the Rotasa Foundation. Additional support for this project has come from Ronald and Anne Abramson, Barbara McFadyen, the Art Jewelry Forum, and Susan Beech. We also thank the many collectors who have so generously lent their Bennett objects for this two-and-a-half-year-long touring exhibition.

Finally, I'm deeply grateful for the thoughtful research, coordination, and expert eye of the guest curator, Jeannine Falino, who has brought this complex project to fruition. Through her we have created a fitting tribute to the artistic vision and productive career of Jamie Bennett.

Gretchen Keyworth
DIRECTOR, CHIEF CURATOR
FULLER CRAFT MUSEUM

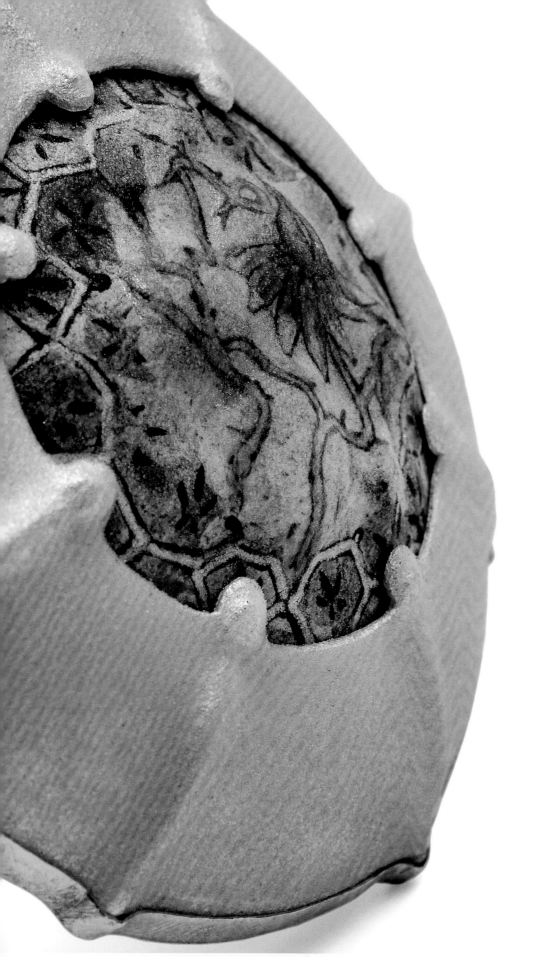

Acknowledgments

Exhibitions are the work of many hands, and I have had the pleasure of collaborating with the fine staff of Fuller Craft Museum in preparing *Edge of the Sublime: Enamels by Jamie Bennett*. I would like to express my deep appreciation to Jamie Bennett for the opportunity to work with him in preparing this exhibition, and to Gretchen Keyworth, the director of Fuller Craft Museum, who, with Jamie, invited me to serve as exhibition curator. Jessie Schlosser, the exhibitions manager, has been helpful in coordinating the project. Donna Eleyi, the registrar, and Pat Warner have provided solid support for the checklist, loan paperwork, and object handling required by the extensive number of loans. The handsome exhibition design by George C. Krauss of Studio GK was expertly installed by Sue Aygarn-Kowalski with support from John Hastie. Many thanks also go to Kristin Villiotte for handling press matters.

The original design and fabrication of the jewelry cases is the work of Mark del Guidice, who especially took into account the exhibition's long tour. I am indebted to him for his contribution and to Will Jeffers of Artex, Susanne Gansicke of the Museum of Fine Arts, Boston, and Mimi Leveque, an independent conservator, who were helpful in selecting case materials. The painstaking work of mounting the ornaments was supervised by the master mountmaker Garrick Manninen and executed by the Wednesday Weavers, Deb Brunstrom, Rosita Corey, Eileen Goldman, Adele Harvey, Barbara Herbster, Gulli Kula, Katie Schelleng, and Norma Smayda, along with Pat Warner and Sue Aygarn-Kowalski.

Sienna Patti of Sienna Gallery, in Lenox, Massachusetts, kindly provided much information on lenders and supported new photography undertaken by Kevin Sprague. Pamela Clark Cochrane of Clark Gallery, in Lincoln, Massachusetts, generously assisted with the artist's framed works of art and wall sculptures.

For this beautifully produced catalogue, we have our publishers, Hudson Hills Press, to thank.

The collectors who agreed to part with their jewelry, paintings, and wall sculptures for this lengthy tour deserve a special word of thanks. In many cases, the loans took place because of the lenders' longstanding admiration and affection for the artist. We are especially grateful to each and every lender for making it possible for us to mount a full and meaningful record of Jamie Bennett's career.

This project has been quietly aided by the loving support of my husband and my daughter, David and Morgan Heath, whom I thank for making all things possible.

Jeannine Falino
CURATOR

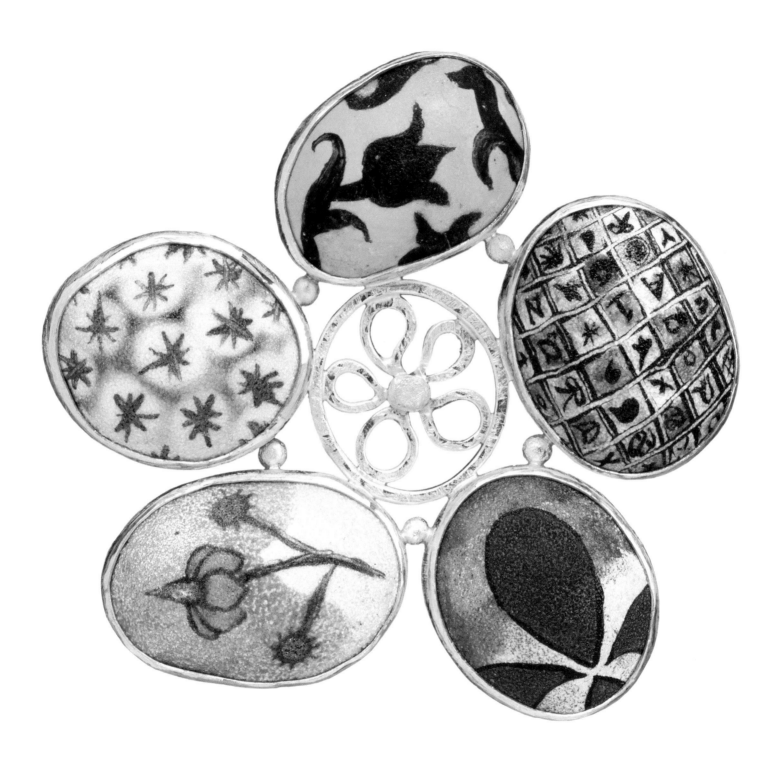

The Contemplative Jeweler | JEANNINE FALINO

With paint, pencil, and enamel, Jamie Bennett achieves uncommonly poetic effects expressed in floral and patterned imagery, and he creates surface interest with a sensuous touch. An iconoclast, Bennett has challenged the paradigms of traditional jewelry forms and hierarchies of art. Over a career that now spans more than thirty years, Bennett has become an internationally acclaimed artist and innovator in the world of contemporary jewelry and enamel.

APPRENTICESHIP AND PRACTICE

A discussion of Bennett's artistic career must begin with an account of the early and enduring influence of his mother, Jean Grippi. At the age of seventeen or eighteen, and without formal training, Grippi moved from Philadelphia to New York City, where she pursued a career in the arts and enjoyed a circle of friends in the field. Grippi eventually became a designer for Henry Rosenfeld, a prominent dress manufacturer in New York, and she worked closely with the designer Joseph Whitehead.

From an early age, Bennett understood and appreciated Grippi's identity as an artist, and by extension, what it meant to be the son of an artist who was also a single mother. In Bennett's case, it meant spending weekdays with his mother's sister and her family in New Jersey and weekends with his mother in the city. This unconventional arrangement worked well, creating a loving, matriarchal family environment even as it exposed him to the excitement of Manhattan and the circle of artists, such as Whitehead, that Bennett met through his mother.

Bennett briefly attended New York University but in 1966 he relocated to the University of Georgia, Athens. At the suggestion of his mother, who wanted a secure career for him, he majored in business. However, by his senior year, the excitement generated by his elective courses in pottery, painting, and metalsmithing convinced Bennett that his talents lay elsewhere.

Among the members of the faculty of the Georgia art department, three professors went out of their way to provide a creative and friendly environment for their students. Ace Olson, a professor of painting, offered support to the fledgling artist, and the ceramist Jerry Chappelle included Bennett among his large and lively entourage of students, friends, and colleagues, but it was the metalsmith Robert Ebendorf who had the most significant influence on Bennett's career. The artist recalls his charismatic teacher as an enthusiastic "bundle of energy," who enjoyed working in the studio alongside his students. He expanded

the students' horizons by holding workshops for visiting artists. In this manner, Bennett met the blacksmith Brent Kington, who taught at the University of Illinois in Carbondale; Philip Fike, who taught at Wayne State University in Detroit; and Gary Noffke, who joined the Georgia faculty in 1971.

Ebendorf had an outgoing spirit and, having studied in Oslo for a year and being a founding member of the Society of North American Goldsmiths (SNAG), had an excellent grasp of the nascent metalworking scene in the United States and abroad. As a self-described beginner who was just finding his way, Bennett was energized by the easy interaction, encouragement, and generous sharing of information that he experienced with Olson, Chappelle, and especially Ebendorf (fig. 1).

Soon after Bennett's mother learned of her son's desire to pursue a career in the arts, she visited the school to meet with his teachers and assess her son's potential as an artist. Their positive responses confirmed her own observations, and her hopes for her son are evident in a letter written in October 1970:

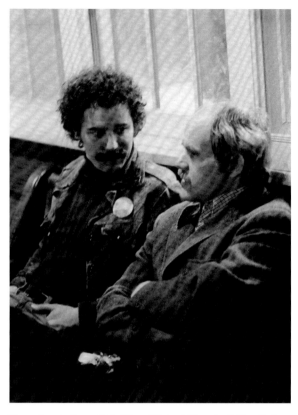

Fig. 1. Jamie Bennett (left) and Robert Ebendorf, New Paltz, 1973. Collection of the artist.

> Jamie, I am happy I came to see you, I can now understand your decision and work better I think you'll do so well, you have the feel for it. I think in all the arts, of course, it is a lot of hard work and you know I'd never say your [sic] good if you weren't. . . . So Jamie, my artistic son take care and continue your work. I certainly was proud of everything I saw that you made, really. Jamie, I'd never say this if I honestly didn't mean it, you should know that by now.[1]

When Bennett's mother passed away shortly after his graduation, these words encouraged him to stay the course and choose a future in the arts. In 1971 he enrolled in graduate school, following Ebendorf to the State University of New York at New Paltz, where he could devote himself to becoming a metalsmith.

By that date, the Department of Fine Arts at the university had just received permission to accept students for a master's degree in fine arts, and Bennett joined as one of the first students in the gold- and silversmithing program. The senior professor at the time was Kurt Matzdorf, known for his whole-hearted commitment to the craft. Highly skilled and disciplined in his approach, he provided the foundation that Bennett needed. On an intellectual level, Matzdorf's love of historical metalwork and his detailed discussions of such acknowledged masters as Cellini, Fabergé, and Lalique balanced Robert Ebendorf's preference for new thinking and methods. Ebendorf encouraged Bennett to experiment beyond traditional forms of jewelry; Matzdorf instilled in him a lifelong pleasure in the study of historic forms and cultures. By turns, these divergent approaches had powerful influences upon his career.

In New Paltz, through Ebendorf's wide-ranging connections, Bennett continued to meet respected craftsmen, including many from abroad. Ebendorf made the most of his contacts and the school's proximity to New York City by inviting visiting metalsmiths from England or Europe to spend a few days in New Paltz. In this manner, Herman Junger, Gerd Rothman, Claus Bury, and Tone Vigeland all found their way to New Paltz and introduced American students to their own work as well as to European trends in contemporary jewelry.

During his first year at New Paltz, Bennett began to study enameling with Matzdorf, using a recent publication by the German-born artist Margarete Seeler as a text.[2] It was fascinating and seductive to work with color but technically challenging because Matzdorf was not an adept enameler. During the following summer, Bennett attended an enameling class at the Penland School of Crafts in North Carolina. The class was taught by William Harper, a craftsman acclaimed for his skill and artistry in the medium. Harper proved to be a generous teacher, as did the talented William Helwig, who held a workshop in New Paltz. With these experiences, Bennett renewed his efforts and began to see greater success in the kiln. Soon he realized that enameling could become an important aspect of his work.

It was an excellent time to join the world of metalsmithing. The field had reached a critical mass that led to the founding of SNAG in 1970 and the conferences that began that same year. In 1972 Bennett participated in the second conference, which was held in New York City, and there he met the jeweler Merry Renk, the blacksmith Albert Paley, Heikki Seppä, who taught at Washington University in St. Louis, and Eleanor Moty, who taught at the University of Wisconsin in Madison. Robert Ebendorf created an unforgettable scholarly experience for members by arranging a visit to the Metropolitan Museum of Art, where they were permitted to handle historic works of art, including a gold Syrian cup that Bennett still recalls with excitement (fig. 2).

The following year, the school's College Art Gallery mounted *The Art of Enamels*, an exhibition based

upon one held in New York nearly fifteen years previously by the Museum of Contemporary Crafts (now the Museum of Arts & Design).³ The New Paltz show was developed by Matzdorf and Ebendorf using works of art lent by the Metropolitan Museum of Art and by contemporary artists. Bennett contributed an essay on enameling techniques for the catalogue, created a didactic case to illustrate these techniques in the exhibition, and assembled an educational slide kit that was lent out by the American Craft Council. It is clear, from these efforts and experiences, that Bennett received as thorough a training in the field as any American metalsmith in his generation.

While still a graduate student, and with Ebendorf's encouragement, he began to participate in exhibitions. By 1972 and 1973, he was already in the thick of things, with shows at Fairtree Gallery, then a new showcase for craft on Madison Avenue in New York City. On a national level, he participated in *Objects for Preparing Food* at the Museum of Contemporary Crafts in New York City in 1972 and in *The Goldsmith*, which travelled to the Smithsonian Institution, Renwick Gallery, Washington, D.C., in 1974⁴

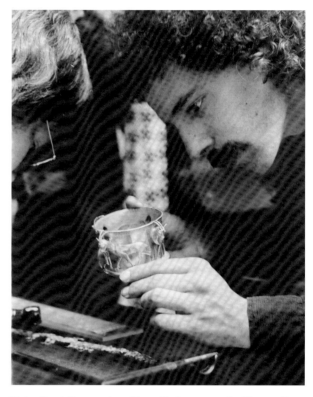

Fig. 2. Jamie Bennett handling a Syrian cup at the Metropolitan Museum of Art, New York, during the conference of the Society of North American Goldsmiths, 1972. Collection of the artist.

The pedagogical side of the craft appealed to Bennett, and following graduation, he took up his first teaching position at Bradley University, in Peoria, Illinois. The school had been established in 1896 as Bradley Polytechnic Institute and in its early days had offered a manual arts program in metalsmithing and watchmaking. Upon his arrival, Bennett saw the remains of the workshops although nothing had been taught for many years. With an equipment budget of five thousand dollars, he set about creating a metals studio. He built jewelry benches using plans designed by Matzdorf and, with two students, began teaching.

But Peoria was relatively isolated and Bennett missed the stimulation of the East Coast. Fortunately, he was able to visit with Eleanor Moty in Madison, Wisconsin, and was befriended by Verne Funk, who was professor of ceramics at Bradley University and among the first Midwestern artists to embrace the California Funk art movement. During occasional trips with Funk to Chicago to visit with artists and see

14 Jeannine Falino

new exhibitions, Bennett became familiar with artists and graduates of the School of the Art Institute of Chicago, including members of the Hairy Who, an iconoclastic group with an early focus on "zits, pits, and furtive sexual encounters" and a socially responsible streak that ran counter to minimalism and other formalist approaches to making art.[5] These visits gave Bennett food for thought as he struggled with his own attitudes toward content, figure, and abstraction. However, he yearned for a more cosmopolitan work environment and looked about for teaching positions in larger cities.

In 1976 he joined the faculty of the Memphis Art Academy (now the Memphis College of Art), a private art school set in a cultural city scene. Bennett had been hired to replace Dorothy Sturm, an enamelist who had taught at the academy for many years. Although he was pleased to find a well-developed enameling studio in place, Bennett was dismayed to find that Sturm's former students remained loyal to her and refused to accept him as their new teacher. He eventually overcame many of their objections and developed his own following, but such frictions prevented him from setting down roots.

Within a year, Bennett began to attend the Summervail Workshop for Art and Critical Studies, a loosely organized but influential summer arts program held in Vail and nearby Minturn in Colorado.[6] Organized by Jim Cotter and Lane Coulter around a theme or medium, the annual workshop attracted artists and educators who sought a community of like-minded people and the opportunity to share ideas and techniques. The beauty of Vail and the energy generated by the program brought participants back year after year. For metalsmiths, Summervail offered an opportunity to reconnect with colleagues, particularly those who moved around the country for new teaching positions. Through Summervail, Bennett kept up with friends in the field and forged new relationships too. The pioneering enamelist June Schwarcz attended, as did Karen Blackman, Martha Banyas, and Kenneth Bates, who by that time had retired from his position as professor at the Cleveland Art Institute; younger artists such as Mary Douglas were hired as summer staff. Bennett taught at Summervail between 1977 and 1984 and coordinated an annual "Great Western Enameling Symposium" between 1981 and 1984.

Beginning in 1979 Bennett served as a visiting assistant professor at Boston University's celebrated but short-lived Program in Artisanry (PIA), alternating with Patricia Daunis-Dunning until he was hired as a member of the full-time faculty in 1981. Established in 1975, the program supported concentrations in a range of craft media including fiber, wood, clay, and metal. Bennett joined J. Fred Woell in the metalsmithing division, pleased at last to have a colleague on the faculty for the first time in his career. Woell was a quiet but engaging craftsman with plenty of content in his work, for he frequently appropriated discarded materials and combined or cast them for his own purposes. Woell was also well connected to the larger metalsmithing community and assisted with SNAG's conference in Boston in 1983. The program accepted many

talented students, Claire Sanford, Charles Crowley, and Tim McClelland among them, but was discontinued in 1985.

While he was teaching in Boston, Bennett observed a change in the field: the marketplace was fostering a different type of excitement as a new generation of wealthy individuals began to collect crafts, particularly furniture.[7] He was surprised to find that graduating students quickly aligned themselves with dealers to place new work in galleries. To a lesser extent, metalsmithing benefited from this trend, and Bennett participated in an increasing number of exhibitions held by private galleries and museums. He held himself somewhat apart from the crush, however, feeling that there was too heavy a reliance on postmodern design and commercialism, with less thought about function or meaning.

These developments also prompted Bennett to turn to painting in order to avoid the commercialism and showiness that he felt had begun to pervade the crafts scene. He had always drawn and painted and during this period he enjoyed the process of painting and creating wall pieces as a means of working out his ideas and figuring out his next step in jewelry. Soon, elements of the floral and domestic subjects that he depicted began to appear in his jewelry.

Beginning in the late 1990s, Bennett began to construct compartmentalized wall reliefs that house paintings and fabricated and found items, assemblages that function as still-life compositions (plate 72). The interplay of the objects illustrates the artist's pervasive interest in joining disparate images, whether in wall reliefs, paintings (plate 81), or jewelry. Similarly, he created reliefs consisting of small, individually composed and enameled copper tesserae. The multiplicity of images and the Scrabble-like possibility of "reading" the tesserae in any direction allow viewers to develop their own ideas about the meaning of these objects (plate 75).

With the closure of the PIA program in Boston in 1985, Bennett effectively ended his journeyman years as an educator and metalsmith. He was hired that same year to replace the retiring Kurt Matzdorf at his alma mater, joining Robert Ebendorf on the faculty, where he remains today.[8] He realized that, up to this moment, he was learning what sort of teacher he wanted to be; once in New Paltz again, he set about becoming that teacher.

During his twenty-one-year tenure at SUNY, Bennett has taken the department to new heights. One significant measure of his success is the number of graduates who have chosen to teach and who are now established at schools around the country. They include Kim Cridler at the University of Wisconsin in Madison, Beverly Penn at the University of Texas in Austin, Tracy Steepy at Rhode Island School of Design in Providence, and Heather White at Massachusetts College of Art in Boston. For Bennett, art education consists of technique and concept in equal measure. Myra Mimlitsch Gray, whom Bennett finds a kindred spirit

well grounded in technique, and who recognizes, as he does, the importance of critical thinking to create works of art, joined the faculty in 1993. Both professors work closely with students to ensure that they explore the history and intellectual perspective behind a work of art as well as its structural integrity and quality of execution. This approach is intended to impart a recognition and respect for the field while providing the students with the encouragement to imagine, create, and discuss their own work by the time they graduate. Rigorous as the process is for the students, Bennett and Mimlitsch Gray find that it also aids in their own creative process. It is for this reason that SUNY New Paltz is considered one of the leading metalsmithing departments in the country.

PRACTICE AND STYLE

An early sketch of a mannequin covered with paper garment patterns (fig. 3) provides the most literal source for Bennett's exploration of these forms, as do actual surviving patterns belonging to his mother that the artist has retained in his studio (fig. 4). Together they document how Bennett's early work originated in these templates for the fashion industry. From these simple pattern profiles, Bennett abstracted the forms and then radically expressed them in enamel brooches, making a visual statement about the process of creating fashion in a piece of jewelry. The pattern shapes absorbed him during the mid- and late 1970s, as borne out by sketches showing forms that were twisted and torn until they were ruptured, shredded, and stitched back together in completely new designs that he committed to the kiln (plate 4). His drawings bear out the endless restating and reordering of these iconic shapes that led him to new and compelling forms. These may be best appreciated in the *Black Fragment* series (plates 4–6) in which the patterns were torn and rendered in an abstract manner that suggested landscapes or crevasses as much as torn fabric.

Most of the designs of the early pattern series in white and black were variations on this theme. With the *Red Site* series of the early 1980s (plate 7), he began a new inquiry that had its origins in a red barn. As before, the forms of the building were splintered into unrecognizable shapes, as were the road and the surrounding landscape, and recombined into a new composition. The introduction of red to this series was his first concession to the power of color in enamel; up to this time Bennett worked with a nearly monochromatic palette, allowing the design to dominate. During this period, the works were roughly square or rectangular, with the viewer's attention drawn to a picture plane whether or not it was encompassed by a bezel setting.

Experimenting with finishes and colors, Bennett was building up assertive shapes, textures, and contour settings. This was the first indication that the frontal picture format that had dominated his work and

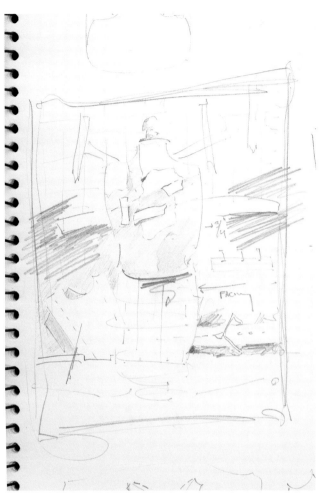

LEFT
Fig. 3. Drawing of mannequin, c. 1982. Graphite on wove paper, Strathmore 400 Series spiral-bound sketchbook, no 1, 14 × 11 in. closed. Collection of the artist.

BELOW
Fig. 4. Jean Grippi, garment patterns, 1960s. Graphite on board, various dimensions. Collection of the artist.

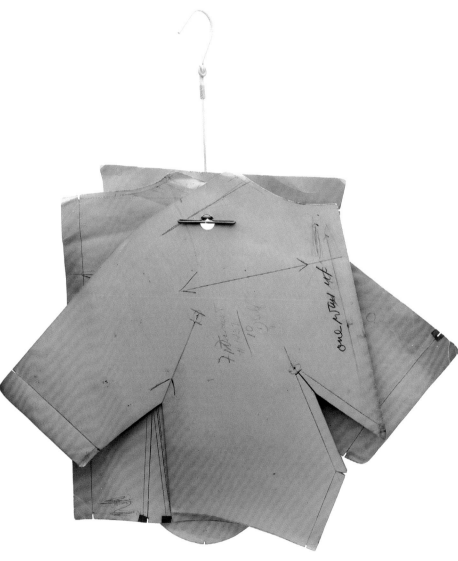

that of most contemporary enamelists had reached the end of its usefulness. The forms that he chose, abstract and related to the human figure, were complemented with an increasingly rich color palette. These approaches can be seen in the *Tesserae, Coloratura, Body, Deerrun,* and *Calypsos* series of the mid- to late 1980s, the artist's inspiration taken from tours through Italy (for the *Tesserae* and *Coloratura* groups), deer tracks, or gestures drawn from dance — all recombined into distinctive compositions (plates 8, 9, 11, 13–19). These works brought Bennett acclaim. His reputation was enhanced through his participation in two exhibitions in the mid-1980s: *Jewelry USA*, which was sponsored by the Society of North American Goldsmiths and The American Craft Museum, and its travelling component, *Masterworks of Contemporary American Jewelry*, one of the first contemporary jewelry shows seen in Europe, held in London 1985.[9] The coral tesserae neckpiece seen in plate 8 was shown in both exhibitions.

The *Priori* series of 1988 was a defining moment for Bennett because the innovative shapes challenged the centrality of gemstones and the ancient practice of framing or mounting stones and enamels. These traditional settings cast a long shadow over contemporary jewelers. With *Priori*, he introduced a radically new approach. "I did not want an institutional 'jewel.' I was interested in the physical sensation, in the instinct one had to bring an intimate object to the body, a more visceral experience. . . . Unfortunately the frame was still a signifier of institutional jewelry, which I did not want." In searching for an alternative, he hit upon electroforming, a method of creating three-dimensional sculptural shapes that "offered the opportunity to break from that stigma to a more instinctive adornment."[10]

Bennett was interested in what ornament had meant at a very basic human level before the first jewelers turned it into a succession of valuable objects made of gold and precious stones. As a return to this far-distant frame of mind, he created abstracted forms that had their source in nature. He chose the word *priori* as a way of signaling that they were "formed or conceived beforehand,"[11] that is to say, before the stylized conventions of jewelry came into existence. These ornaments (plates 23–26) were notable for having slender forms resembling small branches that were enameled in the round. Some were adorned with leaf or featherlike appendages in gold. The innovative shapes had an immediate impact upon the field. Susan Cummins, then director of the eponymous gallery in Mill Valley, California, wrote to Bennett after seeing his show in New York at the CDK Gallery: "The work was spectacular. It seemed so natural or logical to enamel the whole form without the ever-present bezel, something I haven't seen done before in the round as you did it. The restrained addition of gold elements created an elegant juxtaposition to the enamel."[12] Bennett fashioned more electroformed brooches of varying shapes in the *Rocaille* series (plates 30–33), perhaps his most successful, comprising pieces of a featherlike shape that terminated in a scroll or leaf. In breaking with convention and creating a completely original form, Bennett paved the way for a new generation

of contemporary jewelers to create works of art that were unrestrained by the framework of traditional jewelry.[13]

The language used by Bennett for his brooches and neckpieces is an important part of his working method, as each object signifies a different search for beauty. The transitions from the early patterns to those of the *Priori* and *Rocaille* series indicate a process of examination that has moved from the familiar pattern shapes to those found in nature. The next phase of his career indicated his heightened receptivity to works of art: "It is important to me," he states, "that the work, the physical object, is sensual; the work itself not just the image on the work or the idea of the work. Being sensual means that they are active, alive, stirring, they are vulnerable, and revealing. . . . Hopefully it is not just a matter of looking and understanding, but also [of] being involuntarily stirred."[14]

Bennett was most interested in historic Western and non-Western objects that were intimate in scale, devotional or domestic, and always ornamental. Using terms such as *Jurjani*, *composed garden*, *chadour*, and *Safavid*, Bennett began a new series of inquiries into non-Western cultures, especially those of the Islamic world, using the patterns and intense colors that he found in tiles, textiles, and Persian miniatures (fig. 5) as points of departure. These interests had been stoked since 1973, when Bennett made his first trip to Istanbul, and were distilled through trips to Morocco in 1986 and repeated trips to Istanbul in 1982, 2005, and 2006.

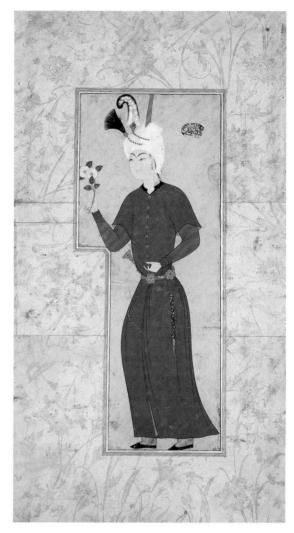

Fig. 5. Possibly Muzaffar Ali, *A Young Prince Holding Flowers*, Persian, Safavid, 16th century. Opaque watercolor on paper, 19 × 12¾ in. overall. Museum of Fine Arts, Boston, Francis Bartlett Donation of 1912 and Picture Fund 1914, 14.590.

His embrace of ornamentation began about 1991 during the *Rocaille* series, when postmodernism had run its course. For many artists of his generation, pattern decoration was something to be denigrated as a "cosmetic garnishing of a form or a picture which was somehow lacking structure and therefore integrity."[15] Modern artists, architects, and design reformers had

rejected ornamentation as superfluous at best and immoral at worst, taking a position that suggested that it was a weak and inferior form of art. Yet the word *ornament* is a synonym for *jewelry*, and Bennett has been instrumental in bringing the term and its various meanings back into currency. The Pattern and Decoration movement of the 1970s constituted the first effort to challenge the stigma that modern art had put on ornamentation, but the artists were few and their influence limited. Thirty years later, as the global village has shouldered its way into the nation's living room, it seems that pattern is everywhere.

The first works in this period were those of the *Jurjani* series (plates 35–38), named for Abd al-Qahir al-Jurjani, an eleventh-century linguist who suggested using ornamentation as a language system.[16] Al-Jurjani was primarily commenting upon the use of calligraphy for this purpose; Bennett used the linguist's name for a series of works in which he reflected upon the range of cultural and intellectual approaches to ornamentation that is available to the artist. Bennett's return to pattern is as remarkable as his return to the bezel setting in which the delicately enameled flowers and fragmentary patterns are set. Many brooches are decorated with a constellation of larger or smaller elements that surround the central form. The works appear at first to be bilaterally symmetrical, but an intentionally uneven layout and the varying shapes give them a playful quality and a sense of movement.

Bennett's new emphasis on pattern was expressed with bolder designs and increasingly brilliant colors. The eye travels continuously about the surface of the brooch from one richly rendered enamel to the next. In other examples, Bennett created larger enamels in gem tones painted with delicate diaper patterns and set them into substantial gold settings of undulating shapes (plate 51). These he called *Safavid* after the sixteenth-century Iranian dynasty. For the *Chadour* series (plates 45–48), Bennett wished to evoke the image of Iranian women in their customary veiled garments against the large and brilliantly sunwashed walls of mosques. Clearly, Bennett's exposure to Islamic culture has had a powerful effect on his art.

In the past six years, Bennett's works have grown larger and more expansive, with increased space for pattern and a sensuous interpretation of nature. The *Florilegium* series (plates 52–55) possesses a new sculptural monumentality even as the decoration, painted with a hair or two of the brush, creates a delicate pattern more like a silken weave than an enamel. His title for these ornaments is appropriate. A florilegium is an anthology, a collection of literary flowers, the name a derivation of the Greek word *anthologion* and implying the importance of each choice item plucked and joined to the whole.

Mosaic Scenarios (plates 56–58, 60) offers a broad surface for the inclusion of calligraphic banners, floral details, microscopic views, and painterly sketches. The artist's brush control and his combinations of color, pattern, and form show a mastery of composition, rendering each one a small masterpiece. One of the chief influences on this series was Bennett's trip in 2005 to mosques in Turkey, where he experienced first-

hand the extraordinary veiled atmosphere caused by the effects of sunlight through window tracery. His attempts to capture this sensation of lace and light may be seen in the accompanying sketch (fig. 6) and in his enamels. The *Urban Traces* series of 2005–2006 (plates 62–66) reflects Bennett's ongoing interest in the botanical and microscopic combined with the depiction of small, overlooked elements in the world. Such modest items, rendered in enamel with Bennett's masterful brushwork, are immensely satisfying and complete worlds in themselves.

Bennett's probing search for meaning in form and decoration defines him as a contemplative jeweler. With the *Priori* series of the late 1980s, he redrew the shape of his field and stimulated a generation of artists. By denying the jewel in jewelry, he created a way to think about ornament in prehistoric fashion—before the goldsmith's art codified it into an arrangement of precious metal and stone. Since that time, he has used pattern to infuse his work with a dense constellation of gemlike decoration, thus reclaiming the jewel on his own terms and joining his love of painting with enamel. Through his writings and teaching, and with his paintings, drawings, and beguiling ornaments, Jamie Bennett has taken us on an intellectual and visual journey that has returned us to our very origins and that points resolutely into the future.

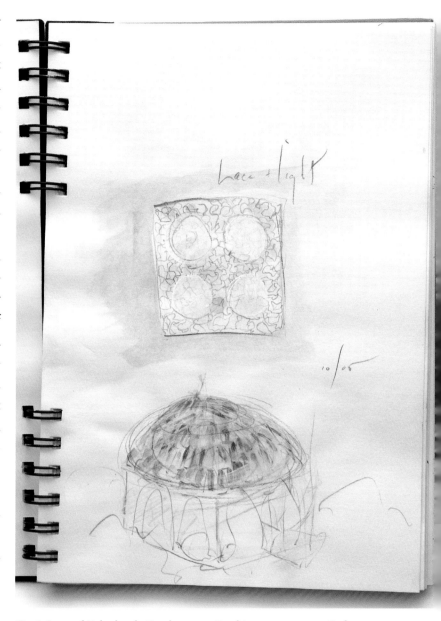

Fig. 6. *Lace and Light* sketch, October 2005. Graphite on wove paper. Cachet Studio spiral-bound sketchbook, 10 × 7⅝ in. closed. Collection of the artist.

NOTES

1. Jean Grippi, letter to Jamie Bennett, October 1970.
2. Margarete Seeler, *The Art of Enameling: How To Shape Precious Metal and Decorate It with Cloisonné, Champlevé, Plique-à-jour, Mercury Gilding and Other Fine Techniques* (New York: Van Nostrand Reinhold, 1969).
3. *The Art of Enamels*, exh. cat. (New York: Museum of Contemporary Crafts of the American Craftsmen's Council, 1959).
4. *Objects for Preparing Food*, exh. cat. (New York: Museum of Contemporary Crafts, 1972); *The Goldsmith: An Exhibition of Work by Contemporary Artists-craftsmen of North America*, exh. cat. (St. Paul, Minn.: Minnesota Museum of Art, 1974).
5. Russell Bowman, cited in John Russell, "Gallery View: 'The Hairy Who' and Other Messages from Chicago," *New York Times*, January 31, 1982.
6. Randy Milhoan, telephone conversation with the author, January 20, 2007. Milhoan spoke on "The Bad Girls and Boys of Metal: The Legacy of Summervail on the Metals Field," at the SNAG conference in 2007. Summervail sessions ran each summer between 1971 and 1984.
7. Edward S. Cooke Jr., *New American Furniture: The Second Generation of Studio Furnituremakers* (Boston: Museum of Fine Arts, 1989).
8. For more on the association of Ebendorf and Bennett, see Vanessa S. Lynn, "Robert Ebendorf and Jamie Bennett: Masters of Matters that Matter," *Art Today* 5, no. 4 (1991): 28–33. Ebendorf left the university in 1989.
9. *Jewelry USA*, exhibition, Society of North American Goldsmiths and American Craft Museum, New York, 1984; *Masterworks of Contemporary American Jewelry: Sources and Concepts*, exhibition, Victoria and Albert Museum, London, 1985.
10. Jamie Bennett, to the author, December 6, 2006.
11. "a priori," as defined in *Merriam-Webster's Collegiate Dictionary: Tenth Edition* (Springfield, Mass.: Merriam-Webster 1977), 58.
12. Susan Cummins, letter to Jamie Bennett, March 9, 1989.
13. Marjorie Simon noted that when Bennett "burst out of the frame he blew out the traditional boundaries of ornament and object" (Simon, "Review of Jamie Bennett at Helen Drutt Gallery, Philadelphia, Pennsylvania [February 10–March 30, 1996]," *Metalsmith* 16, no. 5 [Fall 1996]: 46).
14. Jamie Bennett, "Traditions and Transformations: Working Locally" (lecture, International Enameling Conference, Arrowmont, Tenn., 1998).
15. Ibid.
16. K. Abu Deeb, *Al-Jurjani's Theory of Poetic Imagery, Approaches to Arabic Literature* (Oxford: Aris & Phillips, 1979); and Oleg Grabar, *The Mediation of Ornament* (Princeton, N.J.: Princeton University Press, 1979).

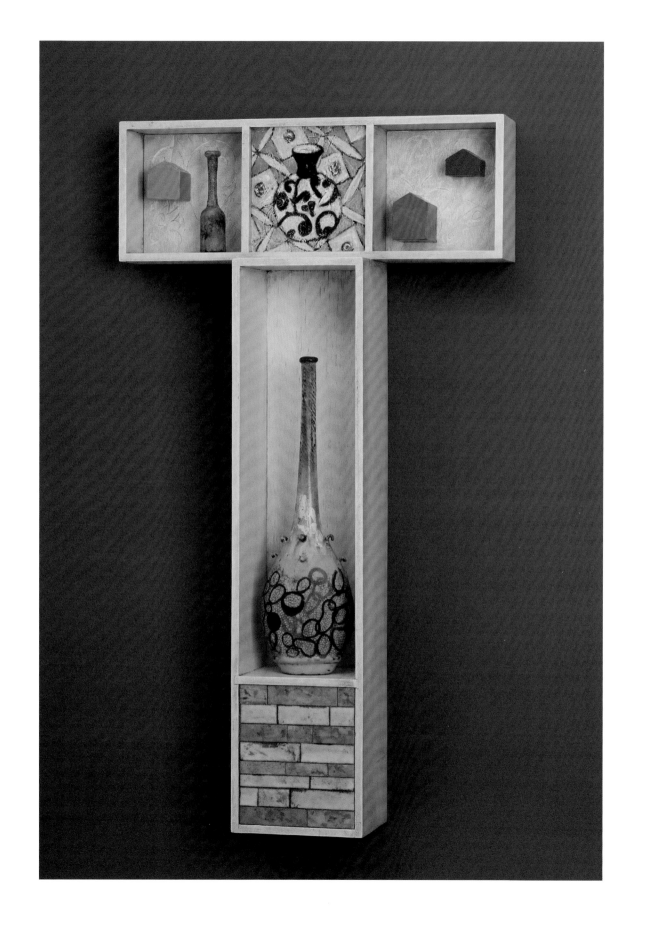

Lost & Found: Meaning & Memory | PATRICIA C. PHILLIPS

> Of what use, exactly? As advocates of intimacy, as embodiments of paradox, as witnesses to earth here, this moment, now. Evidence, thus, that tenderness and style are still the best gestures we can make in the face of death. —MARK DOTY, *Still Life with Oysters and Lemons*

A still life? A constructed poem? A horizontal wooden box with three equal-sized bays rests atop a vertical container in which a vessel sits on a painted stack of bricklike forms. The vessel, with its curved ochre base and long, narrow blue neck, is intricately patterned with hand-painted cross-hatching and interlocking forms. Two of the boxes contain objects—a small vessel and several "floating" houselike forms—each painted a single, deeply saturated color. These boxes flank a central box that holds a painting of another rounded ochre- and black-patterned vase resting in a geometric field of intersecting grids and rectilinear forms. *Melancholia* (1998; fig. 7) represents a succinct interiority of expansive implications. Transposing objects, images, and the more errant qualities of memory, the artist Jamie Bennett explores the endless and often eccentric ways that, through the collection and display of objects of desire, memory, longing, and loss, we make meaning in domestic space. And, although these personal arrangements may be idiosyncratic and fiercely independent, they are neither arbitrary nor incidental. These collections of objects and images as psychological prompts to connect past with present are decisive, if intuitive, illustrations of moments of recapitulation and renewal. Bennett's rootless, archetypal houses, the arrangement of objects with paintings of memories of objects, enigmatic traces, and an ambiguity of surface and depth, register a quiet melancholy of things lost and retrieved—the inevitability of disappearance and impermanence. "To think through things, that is the still-life painter's work—and the poet's. Both sorts of artists require a tangible vocabulary, a worldly lexicon. A language of ideas is, in itself, a phantom language, lacking in the substance of worldly things, those containers of feeling and experience, memory and time. We are instructed by the objects that come to speak with us, those material presences."[1]

In his searching meditation on our deep and irresistible attraction to ordinary things, Mark Doty paradoxically considers and applies the still life and the poem as vivid metaphors for the intangibilities of the human condition. He suggests that "what makes a poem a poem, finally, is that it is unparaphrasable. There

LEFT
Fig. 7. *Melancholia* wall relief, 1998. Polymer, oil, encaustic, enamel, wood, copper, 12 × 24 × 36 in. Private collection.

is no other [way] to say exactly this; it exists only in its own body of language, only in these words.... It's the same with painting. All I can say of still life must finally fall short; I may inventory, weigh, suggest, but I cannot circumscribe; some element of mystery will always be left out."[2]

In 1998, Bennett began a series of painted studies entitled *Still Lifes Tabletops* (fig. 8). Tactically limiting the range of variables, the artist placed a single vessel on an angled tabletop that is covered with a colorful patterned cloth. The background of each painting is richly, if subtly, textured, creating an arresting tension between materiality and space, flatness and unfathomable depth. The vessels are condensed iconic forms that connect and bring meaning to these commonplace but wistfully isolated spaces. The reiterative trope of vessel, tabletop, and domestic space invokes human transactions in the province of objects, artifacts, and things assembled in the course of a lifetime. The genre of the still life historically chronicles people's infinitely complex relationship with inanimate objects—an extensive taxonomy of artifacts and architectures—that we create and organize, and which then imperceptibly, but unmistakably, pattern and shape our lives. This series, in which Bennett strategically examines and transforms the archetypal, represents a principal characteristic of his work. Moving between representation and abstraction, subject matter and visual pattern, the personal and the cultural, his orchestrations challenge us to navigate among meanings available through content (domesticity, memory, loss, imagined and observed landscapes) in the world of things, and from intricate and diverse forms of ornamentation largely based on natural forms and phenomena. "Part of what poetry is, I think, is the inner life of the dead, held in suspension. It is still visible to us.... This evidence that a long act of seeing might translate into something permanent, both of ourselves and curiously impersonal, sturdy, useful."[3]

Doty suggests that art, if ineffably, is the "best gesture" we possess to face inevitable loss—and our own vulnerability and transience. If less profound than facing life's worldly limits and ephemerality, a second lament—especially for those of us who choose to write about art—might be evoked by the "unparaphrasable" character of the poem or painting. Doty acknowledges that, although we may succeed in vivid, evocative description of what is read or seen, exegesis is always a partial and imprecise endeavor. We may experience poetry and art, but our representations and explanations of these encounters never adequately convey the imaginative range or psychological depth of the work.

Rather than proceeding unequivocally and confidently, Doty reminds writers, readers, and participants in art that, even when there is unhesitant response of great conviction, there is more doubt than assurance in the critical engagement of art. Finding words for other works of art is invariably an inexact, if passionate, transaction. What may be presented and parsed in the examined work inevitably contains "some element of mystery" that is always unknowable. As we bring our greatest passion and perseverance to the consider-

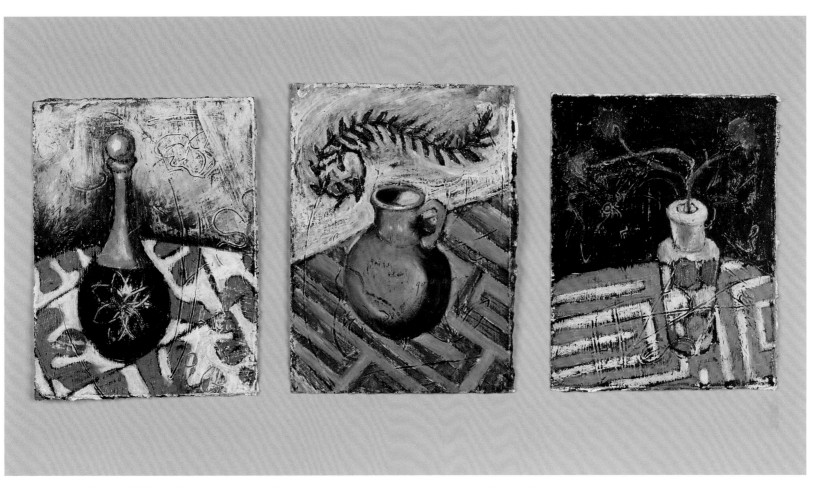

Fig. 8. *Still Lifes Tabletops*, 1998–1999. Oil and polymer on paper. Each approx. 5 × 7 in. Private collection.

ation of art, a self-reflexivity guided and governed by uncertainties concurrently humbles and enriches the writing. This may seem to be a tentative, even apologetic, way to begin an essay on an artist's work, yet my own conviction is that queries and doubts often are the best way to begin — and end — thinking and writing about art. By raising clearer and better questions, we can understand how doubt coupled with belief in art brings us closer to meaningful encounters.

If we do believe in art, do we require it? And, if we accept or question art's necessity, do we expect and seek beauty? And, if we should always fail in some way to express and articulate what art is, can we more confidently, if inconclusively, speculate on what it does — how it performs? More pointedly, if problematically, what is the function of beauty? The philosopher and art critic Arthur Danto has been a consistent and eloquent advocate for beauty. In the essay "Beauty and Morality" he writes on the long affiliation of beauty with sadness. He explores concepts of beauty that apply its seductive lure to bring us into confrontation with dire and disturbing events and ideas, including the elusiveness of art itself.[4] For Danto, beauty is an instrument or vehicle that brings us to a more complex emotional and intellectual reception and response, which, in its absence or our own lack of perception, we cannot access or experience. Other writers, challenging Danto and his fellow defenders of beauty, insist that beauty and difficult ideas are incompatible and irreconcilable. The salient issue — or question — of Danto's position is, what is the relationship of beauty to content? Is it enough for art to be beautiful? Or, more relevant, is it possible for beauty to have an affective resonance without content? Most of us have come to accept that beauty is contingent and transitory — that its qualities and characteristics are neither timeless nor universal. Beauty is as beauty does: it is culturally, historically, and circumstantially determined. It was Jean-Jacques Rousseau who observed, "As emotions were the first motives that induced man to speak, his first utterances were tropes. Figurative language was the first to be born. At the beginning, only poetry was spoken."[5]

Returning to Doty — and Rousseau — how does the beauty and mystery of the poem or still life lead us to the difficult and melancholic? Is beauty an ineffable mystery or is it an agent that inexplicitly guides us to what we might understand — even while accepting what we can never fully know — about art. These impelling, unrequited speculations lead us to the experience of difficult beauty or beautiful doubt in Jamie Bennett's work and practice. His work can be imagined and interpreted as independent poems or tropes that use a condensed, epigrammatic format to release questions of consequence. Poetry can guide us to the most nuanced, yet urgent emotions of the human condition and yet generally its form and structure are more self-restrained than those of the novel, for instance, with its more digressive scope. It is ideas of contraction and expansion, density and discursiveness that lead us to an understanding, albeit partial, of what Bennett's work is and does in the contemporary world. While Bennett paints and presents objects in

self-contained environments, jewelry may be his most expansive and distinctive format. While I will consider the range of this work, his brooches and other jewelry are invariably expressions of his vivid visual language.

Like architecture, jewelry may be considered to have a use or application. Our bodies provide a setting—and the architecture—for jewelry. We offer the structure, the enfleshed and clothed contours, and endless opportunities for its presentation in motion, in different situations and countless configurations. In a critical reflection on difficult beauty, is jewelry ever difficult? Jewelry can be stunning, striking, ugly, uncomfortable, or boring, but can it be difficult? Can it be—and why might we want or expect it to be—challenging or disquieting? Unquestionably, Bennett's work attracts, delights, and charms with its striking intricacy and its scaled-to-the-body format. So, while we acknowledge some of the most apparent qualities of his work, it may be fruitful to turn the tables in order to consider how, when, and why the artist might aim for doubt and difficulty. I am interested in how ideas of ornament communicate and create a conceptual complexity in the work. In the same way that writing can take different forms, Bennett deploys a range of genres—paintings, constructed objects, and brooches—to explore ideas of perception, intelligibility, and communication, and there is an unmistakable relationship—a productive sustainability—in the different bodies of work that he produces.

As we look at Bennett's work, we see that the genre or subject matter both spans and vacillates between landscape and still life, texture and ornamentation, form and material. Yet before we consider what Bennett does, it may be useful to consider what this work implicitly critiques. While we may equivocate about whether we are in a post-postmodern age, we have surely entered a post-manifesto, even post-ideological age. A surfeit of new processes and technologies, makers and making, products and objects spans the vast range of scales of economy and production, but the current ideological apparatus has not confirmed a dominant theory or ideology.

With other artists, architects, and writers of my generation, I was deeply influenced by Robert Venturi's *Complexity and Contradiction in Architecture*. The spirited and prescient text identified and articulated some of my own frustrations with architecture and design, and I was intrigued that Venturi described this passionate, polemical project as a "quiet manifesto . . . guided by precedent thoughtfully considered."[6] Upending half a century of modern architectural discourse and production that often included the suppression and exile of history and ornament, he (perhaps unintentionally) invoked the imminent vulnerability of the manifesto in the late twentieth century. In the first half of the twentieth century, the manifesto was an expected and emphatic way to influence and strengthen discourse on art and architecture. In 1908, Adolf Loos published "Ornament and Crime," an essay that became an intellectual staple of early modernism.

Conflating the development of the human embryo with the progression of so-called developed culture, Loos discovered and then disseminated the following truth: "Cultural evolution is equivalent to the removal of ornament from articles of daily use."[7] He goes on: "Whoever goes to the Ninth Symphony and then sits down to design a wallpaper pattern is either a rogue or a degenerate. . . . Lack of ornament has pushed the other arts to unimagined heights. Beethoven's symphonies would never have been written by a man who was obliged to go about in silk, velvet and lace."[8] A century later, Loos's ideas may resemble a disturbing rant, but it would be an oversight to dismiss his perception that human individuality and subjectivity had become so secure and pervasive in the early twentieth century that the distinctions—or diversions—of decoration and ornamentation were neither justifiable nor required. The force of the individual could be expressed—in fact, would be more insistently communicated and performed—without the superlatives or superficialities that Loos ascribed to ornament.

This aesthetic restraint gained currency and recapitulation in the work of the art critic Clement Greenberg. In a fascinating essay, "Notes on Surface: Toward a Genealogy of Flatness," David Joselit examines Greenberg's defiant, if troubled, defense of the unembellished picture plane—painting about painting in the most austere self-referential way—as the only appropriate representation of psychological depth. Joselit goes on from a discussion of Greenbergian formalism to consider how postmodern flatness connects ideas of the image and identity in contemporary life.[9] He speculates on the relationship between flatness and earlier traditions and attempts to find affinities in ideas of flatness. Joselit does not address the concept directly, but it is clear that flatness and ornament have had a long and fraught alliance.

A consideration of Bennett's work and, in particular, of his engaged theoretical position regarding ornament, suggests that his work bridges pre- and postmodernism. For Bennett, ornament effectively and agilely spans and connects history and contemporaneity, form and flatness. Both discursive and recursive, the work embraces a range of cultural and personal sources and influences. Bennett draws upon cultures and eras when ornament was not scorned but instead was embraced and understood as a resonant, communicative, and necessary visual and intellectual resource. Rather than something dismissed as dispensable and superficial, ornament was (or is) a visual syntax in which ideas form and reside.

Bennett's engagement with ornament has been a slow, deliberate unfolding and excavation of culturally and personally derived ideas of abstraction and representation. His earliest preoccupations as a metalsmith are reliably represented by the *Pattern* brooches of the 1970s (plates 2–4). They are flat, planar, folded, architectonic, colorless, and austere. Like pressed and stacked dress shirts, they convey a meticulous order, pointedly representing the conventions that, at the time, governed ideas of modern art and of an ordered—and orderly—formalism. These early brooches are self-contained and self-referential. Although

not faithfully modeling Greenberg's advocacy of painting's flat, resolute autonomy, this body of work appears unaffiliated with, if not independent of, a broader social context. As Greenberg claimed for painting, flatness and abstraction represented and released a transcendent, emotional depth resolutely estranged from the quotidian. The flatter the deeper is a dependable, if glib, aphorism. But just as other artists and contemporaries experienced a dissatisfaction and exhaustion with the unyielding tenets of modernism, Bennett ignited the engine of material investigation and color to expand and liberate his work from restrictive conventions and entrenched theories in the field. Color, once perceived with skepticism, became an element and agent in his work, as well as a catalyst for an expanded scope of research. Forms and shapes became more organic, independent, and eccentric, actively engaging and embracing the space around them. Increasingly influenced by the objects and spaces that organize people's lives and, at times, overly determine their behavior, Bennett also found the natural environment, the development of forms through accretion, and the strange vagaries of cellular growth fruitful and promising conceptual resources.

The relationship of ideas and material experimentation offers a particular perspective on innovation. There have been significant shifts—indisputable moments of rift and change—in Bennett's creative work over more than a quarter of a century. In the early years, he perceived and developed his brooches as small (perhaps wearable and performable) paintings. But by the mid-1980s, the amicable relationship between painting and jewelry—painting as jewelry—presented a moment of productive crisis and imminent shift. Limited by the format of both painting and conventional jewelry, a limitation perhaps most problematically represented by the frame, Bennett questioned the isolation of the painting supported by and cordoned off by its frame. In a period of restless yet strikingly productive research and experimentation, he sought a way to think about materials as autonomous structures and reflected on ways that art—and jewelry—could find and bring meaning to life. For him, as for other artists practicing at this time, the modernist firewall between art and life, between aesthetic austerity and life's messy impurities, became a point of critical contention and preoccupation.

This was when Bennett, now renowned for his innovation in the technique, first began to work with electroformed copper. The process of creating hollow copper forms freed the artist to think in three dimensions and to expand the format of his future work dramatically. His innovation acquired an additional refinement when Bennett applied his marvelous facility for enameling to the surface of these often irregular copper forms. The results precipitated another opportunity for Bennett to reconsider, in his own work, the once-disdained subject of ornament. The liberation of electroforming, coupled with the striking textures and luminous colors of enamel, inevitably made ornament permissible. In spite of the influence of Loos's diatribe against the superficialities and indignities of ornament (particularly in and on archi-

tecture), Bennett turned to the long history of architectural—and architecture as—ornament. His new forms led Bennett to architecture as a way to expand on and theorize about ideas and issues that emerged from the new methodology.

His ideas were powerfully galvanized and advanced in the *Rocaille* series (1991–1992) (plates 30–34). The enamel on the odd, organic shape of electroformed copper is influenced by baroque and rococo architecture. The somewhat awkward and unstable form has an unsettled quality, concurrently referencing plant forms, ocean life, and human organs. The color is applied in agitated layers, responding to and actively accentuating the rounded forms and volumes of the brooch. While this new methodology created a new aesthetic repertory for the artist, Bennett's work continues to develop in a spiral fashion, both linear and cyclical in character. There are fruitful and ambitious trajectories of experimentation, research, and innovation in his practice, but he continues to work on recurring themes, often returning to older processes and formats in a sense of urgent renewal.

Seeking a reconciliation of contemporary ideas with ornament, Bennett turned his attention to an historical range of architecture, including Renaissance, baroque, and medieval Islamic manifestations. In *The Lost Meaning of Classical Architecture: Speculations on Ornament from Vitruvius to Venturi*, George Hersey examines the derivatives of ornamental forms in Greek and Roman architecture. Not necessarily a direct influence on Bennett's work, Hersey's thesis nonetheless offers relevant theoretical background:

> It all becomes more curious when we reflect on the actual content of this architecture and meditate on the names of its ornamental components. Why at great expense do we have stone-carvers make replicas of beads, reels, eggs, darts, claws, and a type of prickly plant, the acanthus? . . . Why wrap a courthouse in what an ancient Greek would interpret as the garlands or streamers used to decorate sacrificial oxen?[10]

Hersey explores, as he suggests, the "holy" and the "unholy" of architecture and ornament.[11] Yes, ornament does frequently reference nature—eggs and eagles, bones and botany—but Hersey demonstrates that ornament is intricately connected to ideas of sacrifice, victims, taboos, the abject, and fear. As Nietzsche writes: "Inexhaustible meaningfulness hung about . . . [the] building like a magic veil. Beauty entered the system only secondarily, without impairing the basic feelings of uncanny sublimity, of sanctification by magic. . . . At most the beauty tempered the *dread*—but this dread was the prerequisite everywhere."[12] For cultures and civilizations, ornament has traditionally been the conveyor of difficult meaning; Hersey suggests that its lost—or found—meanings are strikingly complex, contradictory, and yet unmistakably connective. His examination of the "unholy" of classical ornament uncannily connects the concept to Danto's

ideas of beauty in extremity. We may associate ornament with beauty, but it is not necessarily always pleasing or sanguine—and is rarely arbitrary or inconsequential.

Ornament started—and continues—to bring difficulty to Bennett's work. At the same time that he worked on *Still Lifes Tabletops* and *Melancholia*, he began a new series of brooches that signify another emerging direction and preoccupation. Bennett's earlier research focused on developments in Western art and architecture, but in the mid-1990s he began to study more closely the traditions of pattern and ornament in medieval Islamic art. Concurrently, he was reviewing ideas of format in jewelry and began to investigate ways to innovate within more formal and conventional modes of presentation. He returned to the idea of the frame—an edge articulated unambiguously. But the liberties and eccentricities achieved in his work with electroforming with enamel ushered in fresh inventions and new irregularities. The *Jurjani* brooches (1997–1998) (plates 35–38) were inspired by Abd al-Qahir al-Jurjani, the eleventh-century linguist who defended the independence of form from more culturally coded meanings. As Bennett's historical and contemporary investigations of ornament and pattern confirmed, the decorative possesses a theoretical and affective significance. This series has a nucleated structure: a large center element, which is set in an irregular gold frame, is orbited, as it were, by smaller bodies. The enameled, highly worked and textured surfaces present a thoughtfully orchestrated cacophony of visual patterns. Connecting to the intricacies of cellular, as well as cosmological, structures and the movement of planets and moons, the brooches are eloquent, elegant metaphors of the diagrammatic impulse—the ways that human beings create models or maps to understand phenomena. Not only do these stunning brooches represent social and scientific phenomena, but also they demonstrate another enduring challenge of Bennett's work.

This and other work challenges us to see, think, and behave in response to ornament. Examining the structure and semiotics of ornament across cultures and throughout history, James Trilling traces and critiques a fear or mistrust of ornament that has been expressed in twentieth-century Western cultures.[13] In addition to some of the theoretical challenges to ornament (precipitated by Loos and others), cataclysmic industrial and technological changes led to a simplification, marginalization, and aggressive editing of the decorative. Examining the trajectories of the birth of modernism and the death of ornament in the twentieth century, Trilling presents a less polarizing analysis. By using the natural, intrinsic patterns of wood and stone, Loos, while abolishing certain kinds of ornament, actually invented a new language of modern ornament. Trilling argues that Loos and others developed a modern aesthetic of ornament based on ideas found in natural forms and absorbed and incorporated into the work of artists. Dismissing the artificial, superficial, and possibly the historical, this new ornamental sensibility was philosophical, polemical, and pointedly connected to the time. As Trilling writes: "The twentieth century saw both the proclaimed triumph of

dogma over ornament [and] the covert triumph of ornament over dogma. Ornament has survived and even flourished in the shadow of modernism, but it has had to adapt."[14]

Bennett's most recent exploration of the role of ornament in architecture, objects, and jewelry took him to Istanbul, where he focused on mosaics — the improvisational colors and materials in this city that is suspended between Islam and Christianity, between authoritarian traditions and democratic governance, between history and rapacious new urban development and cultural change. *Mosaic Scenarios 1* (2005) (plate 56) is a piece that suggests another juncture and point of synthesis for the artist. The enamel and copper brooch sits in a delicate irregular gold frame. The surface combines — and reconciles — ideas of independent painting with abstract patterning, landscape with interiority. The lower section is a crackled and fissured black plane on which red highlighted egg-shaped forms are scattered. Above this, silhouetted plant and other errant forms (clouds and currents) invoke a quiet tension. Not simply because of the subdued palette of colors, the brooch has a dark, slightly ominous quality. Its twilight — and difficult — beauty represents a melancholic acceptance of the loss, dislocation, and mystery of the human condition.

The rich, if problematic, legacy of ornament in the past century serves as a metaphor for Bennett's own adaptive and independent practice. Part of the concept of loss in the work is the artist's ongoing recapitulation of the language and muteness of things that we make and possess. With compelling insistence, this visually captivating work is about lost meanings and recovered memories — about the perennial struggle of dogma and doubt in our world of ideas and things. Bennett's strikingly beautiful brooches, paintings, and constructions are difficult. Not only does his work suggest that ornament is a fruitfully problematic contemporary issue, but also, and more poignantly, it is so evidently about — and serves as a trope for — vulnerability and loss. Unlike amulets that carry a perceived magical and protective power, Bennett's work is about exposure and vulnerability. Moving agilely between materials and formats, he is a semaphorist arranging form, color, movement, and ornamental language in a prescient visual system of images and forms. His imaginatively discursive work demonstrates time and again that there are "no ideas but in things."[15]

NOTES

1. Mark Doty, *Still Life with Oysters and Lemon* (Boston: Beacon Press, 2001), 9–10.
2. Ibid., 70.
3. Ibid.
4. Arthur Danto, "Beauty and Morality," in *Uncontrollable Beauty: Toward a New Aesthetics*, ed. Bill Beckley and David Shapiro (New York: Allworth Press, 1998).
5. George Hersey, *The Lost Meaning of Classical Architecture: Speculations on Ornament from Vitruvius to Venturi* (Cambridge, Mass.: MIT Press, 1988) Quoting J.J. Rousseau, "Essai sur l'origine des langues" (1793).
6. Robert Venturi, *Complexity and Contradiction in Architecture* (New York: Museum of Modern Art, 1966), 13.
7. Adolf Loos, "Ornament and Crime," in *Adolf Loos: Pioneer of Modern Architecture*, ed. Ludwig Munz and Gustav Kunstler (New York: Frederick A. Praeger, 1966), 226.
8. Ibid., 231.
9. David Joselit, "Notes on Surface: Toward a Genealogy of Flatness," *Art History* 23, no. 1 (March 2000): 19–34.
10. Hersey, *Lost Meaning*, 1.
11. Ibid., 156.
12. Friedrich Nietzsche, *Human, All-Too-Human*, quoted in ibid., 44.
13. James Trilling, *The Language of Ornament* (London: Thames and Hudson, 2001), 23.
14. Ibid., 185–87.
15. William Carlos Williams, "No ideas but in things," in *Selected Poems by William Carlos Williams* (New York: New Directions Books, 1962).

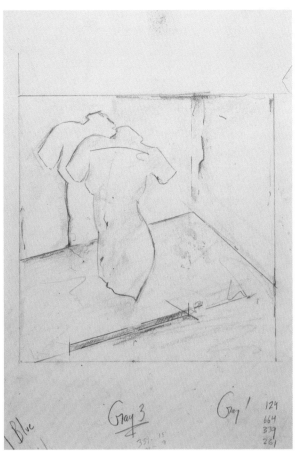

LEFT
Fig. 9. Study for figure and ground, 1982. Graphite and colored pencil on wove paper. Strathmore 400 Series spiral-bound sketchbook, no. 2, p. 53; 14 × 11 in. closed. Collection of the artist.

BELOW
Fig. 10. *Figure and Fragment*, 1982. Enamel, copper, wood, 9 × 15 × ½ in. Collection of the artist.

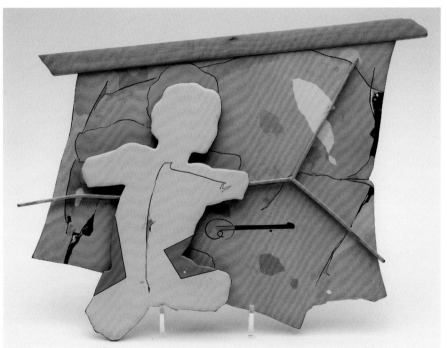

Drawing Out Ideas | KARL EMIL WILLERS

> I want to disturb the forms of jewelry—redefine the idea of appropriate emotive jewelry.
> —JAMIE BENNETT, 1999

The history of the sketch and its critical reception in the West provides one avenue for recounting the entire history of modernism. Over the course of the nineteenth century, graphic notation increasingly came to be appreciated as a work of art in its own right. Traditionally considered an initial step in the long and involved process of creating a finished composition, the sketch was increasingly praised for its distinctly contemporary qualities. In an era when all appeared fleeting and mobile, changing and transitory, the quickly rendered drawing was recognized as a particularly adept means of capturing the shifting and unstable, the brief and ephemeral aspects of life.

A study of Jamie Bennett's many sketchbooks reveals that he works back and forth between rapidly executed, exploratory works and carefully rendered drawings that serve as a guide for his work at the bench. The spontaneous elements found in many of his sketches reveal his experimentation with ornamental shapes, colors, and studies from nature (plates 87, 90–91). He also employs a precise working method in preparing finished pencil-and-watercolor sketches with fully rendered linear designs, subtle washes, and color shifts, intended as a guide for its transformation into enameled jewelry. The finished appearance of an ornament is clearly evident in drawings that are rendered to scale and with considerable detail; when a brooch is laid upon its preparatory sketch, it matches the drawing's contours and design with astounding precision. In these two-dimensional drawings, Bennett addresses himself to his three-dimensional objective (plates 44, 88).

The artist's frequent marginal notations in these working drawings illuminate a creative process that is both visual and formulated in text. For Bennett, writing is a way of thinking about the process of making art as well as a way of noting more prosaic details about surface treatment: "Try to get the soft wet quality of watercolor in the enamels—like that."[1]

Text forms a backdrop to sketches made by Bennett in 1982 for enameled wall reliefs that depict the outline of a torso, the sketches based upon studies of classical sculpture and pictured against an abstract field (figs. 9, 10). Many comments in the notebook suggest that the artist struggled to balance the figural (foreground) and nonobjective (background) elements in these compositions. His difficulty in resolving this duality is illuminated in an accompanying autobiographical passage that revealed his similar unease

with the disjointed experience of living in New York and New Jersey, between family ties and being on one's own, between an imaginative and an everyday life:

> There is simplicity and stability—honesty—yet a fear of commonness in my practical life. There is complexity, excess, and a certain frivolousness in my NY life. . . . Sometimes I do feel like two people. I know my recent work is about both of me. I have suppressed the practical me—not thinking it was very important before. Now I know it is the fragment that I have not shown and must begin to come out. The torso and bottle forms are merely something to hang this on. Each piece should develop from an understanding of background. I'm interested in what it is from my early life that has shaped the things I actually am and the things I prefer to be—this duality is and has been influenced by my trafficking between NY, my mother's home and my passionate home—and NJ, my actual home and practical home. I want to manage to put these pieces together.[2]

The works modeled upon these sketches address Bennett's effort to resolve the figure with abstraction, an effort that he ultimately abandoned: "It seems when I use the figure I move to a suggestion of narrative and a relative pictorial space. This is not what I want. I am interested in representation as a means of developing temporal space—TIME—and being connotative—not linear explanations. It seems as I use the figure it freezes in a dead and explicit moment. I will have to decide if it is worth preserving."[3]

Among the drawings and notes in this sketchbook, the seeds of a new idea were interspersed, using the possibilities for what Bennett has called his "fold-over" jewelry designs. Taking trapezoidal pieces of paper no more that a couple of inches wide, he made a single fold, overlapping one part over another in order to create a variety of more complex forms (fig. 11). These cut and folded "drawings" led Bennett toward a series of geometrically shaped and patterned brooches that resemble the reductive palette and serialized inventiveness of minimalist painting.

The fragmented figure seen in Bennett's earliest sketchbooks and drawings appears throughout his career. By the mid-1980s, the silhouette of a sculptural fragment from classical antiquity was supplanted by the more obtuse bodylike form of a bottle or vessel. Over time, other imagery, patterns, and shapes that he recorded formed an entire repertoire of iconic imagery. One notebook from 1992, for example, contains a panoply of subjects—pitchers, bells, curvilinear shapes, fish, pears, entire still-life settings, tables, leafy stems, vessels, candelabra, human figures, birds, spoons, cups, bottles, architectural metalwork, floral designs, cottages, village scenes, dress forms, boxes. By the 1990s, these studies contributed as much to Bennett's paintings as to his jewelry.

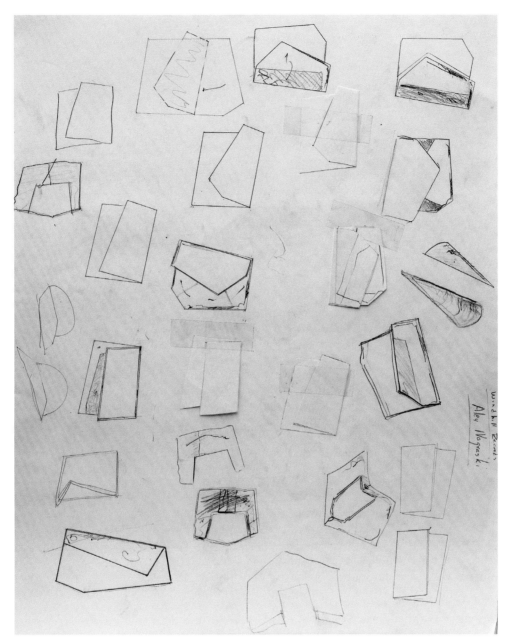

Fig. 11. Sketches of fold-over forms and folded paper, c. 1983. Graphite, cut and folded sheets of paper, and adhesive tape on wove paper. Strathmore 400 Series spiral-bound sketchbook, p. 51; 14 × 17 in. closed. Collection of the artist.

The sketchbooks represent scattered parts and pieces of a puzzle. If the sketchpads have a recurrent theme, it is their very lack of any single coherent pictorial subject or overridingly consistent textual narrative. What is evermore pronounced is a diverse and disjunctive experience of the world—a sense that things do not always fit together in a logical pattern or expected fashion. Drawings introduce one subject after another in a long series of encounters, incidents, and occurrences without a fixed resolution, evidence of the artist's own ruminations over the purpose of composition and content.

> "Unorganized"—something that results from the use of the fragment is the question. Why must it be put together in an orderly fashion? That is a question for all of jewelry—decisions seem to be made on the finality of the orderliness. Even the most informal of ideas is restricted to this action of putting it in order to be a proper jewelry context. These new pieces are a challenge to that basic pretext of jewelry. *Unorderliness is OK*. I must concentrate—that is allow myself to relax enough to capture the gesture of relationships—not force them—not make parts look like they go together.[4]

This trajectory led Bennett to experiment. No longer a single or unified form, the shapes of his brooches became conglomerations and accumulations. At the same time, his drawing style became looser, increasingly more painterly and gestural. Many sketches took on a calligraphic quality, acquiring baroque elements in their liberal application of decorative flourish and ornamental detail (plate 86). Whether from cause or effect, these freer explorations in drawing coincided with Bennett's development of the electroform process that allowed for more idiosyncratically and organically shaped jewelry forms. When immersed in an electromagnetically charged bath of pulverized metal filings, any form modeled in wax emerged encrusted in a lightweight metallic shell that could be further worked and crafted into a finished piece of jewelry.

By the end of the 1990s, sketches for increasingly ambitious forms began to appear. Some notebooks are largely devoted to studies for intricate wall units that took the forms of frames and boxes and shelves that enabled him to assemble disparate elements into a pleasing whole. This phase arose from earlier ruminations on massing disparate forms: "Framed fragments. I have several ideas on ways of accumulating fragments. The frame is a reasonable device."[5] Various objects were arranged within these works, sometimes a bottle or vase or vessel was incorporated, a substitute or stand-in for the human figure. These conglomerations formed intriguing yet inscrutable still-life settings (plate 72).

> Still life in and on the shelf—a cultural composite a collage—array and disarray. Bounty parading the still life has always acted as a symbol of drawing—the disarray of images interacting—a collection—whatever is on the shelf can be enigmatic—we know it so well—

but puzzled why it is there, what it is for. These are an inventory of one thing over and over deposited on a grid—harmonious & distant.[6]

The appeal of the grid soon became apparent in wall sculptures that were covered with small enameled tiles, or tesserae, each decorated with a discrete image or scene. Juxtaposed one against the other, the tiles sometimes cohered into a single picture; elsewhere the odd tile broke up a continuous pattern. Some tiles were unique, stand-alone tableaux—compositions in their own right, with little or no relation to any other element. While some tiles were obvious variations on a theme, others were scattered about with seemingly random abandonment.

> Tesserae. The idea of fragment continues to come up—it's perhaps part of the way I feel—nothing ever seems to conclude—things have vague relationships. It's either everything is part of one or nothing of each other. I'm really not sure. I don't think I want to find out. I am going to start on some of the tesserae wall pieces. They will include figurative suggestions and elements. Placement will be subordinate. As I've said before, the figures are just another element. The feeling for a space or idea is not dependent on them.[7]

The compartmental division created by the placement of one small tile against another is a predominant characteristic of Bennett's painting. The artist tends to partition and separate the paper or canvas into several distinct areas, each section of which is devoted to a very different category of imagery—a finely rendered landscape here, a sinuously worked floral design there, and all refined to what can only be described as a jeweler's finish. This tendency can also be traced within Bennett's jewelry compositions: "necklace—while each element is meant to be a point of contemplations—a spot to concentrate & spend some time with—it co-exists with other equally demanding elements—(noisy) encyclopedic but worth the time at each spot.—To look at as a whole—difficult to find a rhythm other than the repeated form—looked at each one microcosmically—microculturally."[8]

The format of the sketchbook lends itself to an exploration of the simultaneously relational and disjunctive. The spiral-bound book of drawing paper holds together pages displaying both patterned variations and disparate notations, in sum compiling an encyclopedic compendium of visual ideas. Unbound and spread out, the drawing book's pages repeat the amalgamation and disjointedness apparent in the artist's other works, whether jewelry forms, painted compositions, or sculptural objects. In this sense, the sketchbook itself can be seen as a prime metaphor and ultimate source for Bennett's art: "The book form has many possibilities. It is a shape of multiplicity/idea."[9]

NOTES

All sketchbooks collection of the artist
1. Grumbacher Utility sketchbook, 1999–2001; p. 13.
2. Strathmore 400 Series spiral-bound sketchbook, 1983; p. 108.
3. Sennelier Croquis spiral-bound sketchbook, 1992; p. 44.
4. Holbein spiral-bound sketchbook, October 1984; p. 17.
5. Ibid., p. 15.
6. Cachet Studio spiral-bound sketchbook, Summer 2005; p. 15.
7. Strathmore 400 Series spiral-bound sketchbook, 1983; p. 61.
8. Bindewerk felt-covered sketchbook, March 2006; p. 19.
9. Strathmore 400 Series spiral-bound sketchbook, 1983; p. 53.

PLATES

JEWELRY

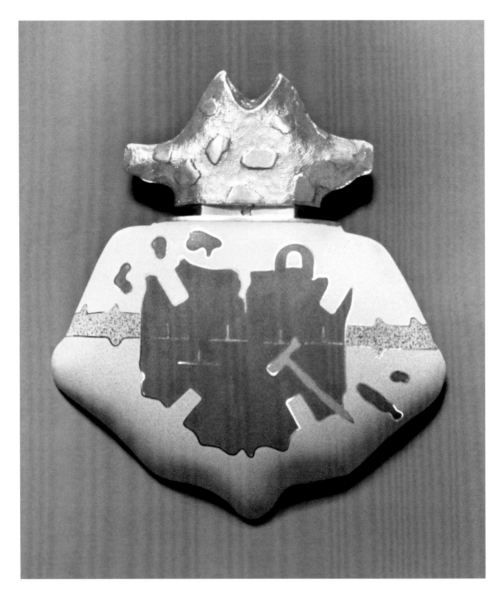

Plate 1 *Silver Fleece*, 1976–1977
Enamel, copper, silver
3 × 2⅝ in.
Cat. No. 1

46 *Jewelry*

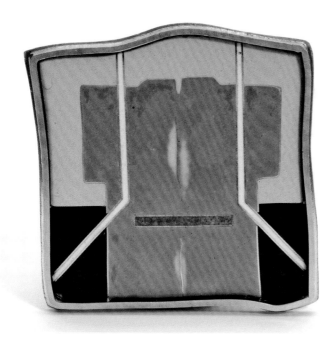

Plate 2 *Shirt Pattern 3, White* series (neckpiece), 1977
Enamel, copper, silver
1⅝ × 1¹³⁄₁₆ in.; chain: 17½ in.
Cat. No. 2

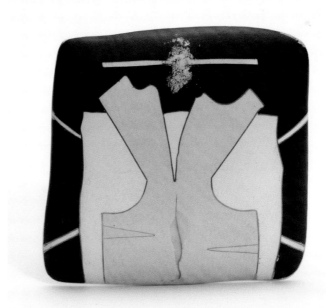

Plate 3 *Raglan, White* series (pendant), 1979
Enamel, copper, silver
2¼ × 2¼ in.
Cat. No. 4

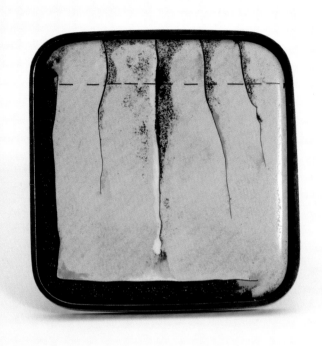

Plate 4 *Pattern, Black Fragment* series, 1978
Enamel, copper, silver
1⅞ × 1¾ × ½ in.
Cat. No. 5

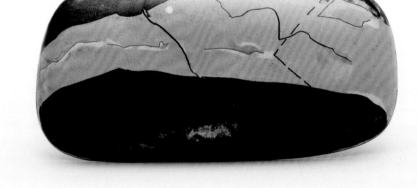

Plate 5 *Black Basilica 15, Black Fragment* series, 1979
Enamel, copper, silver
1¼ × 3¼ in.
Cat. No. 6

48 *Jewelry*

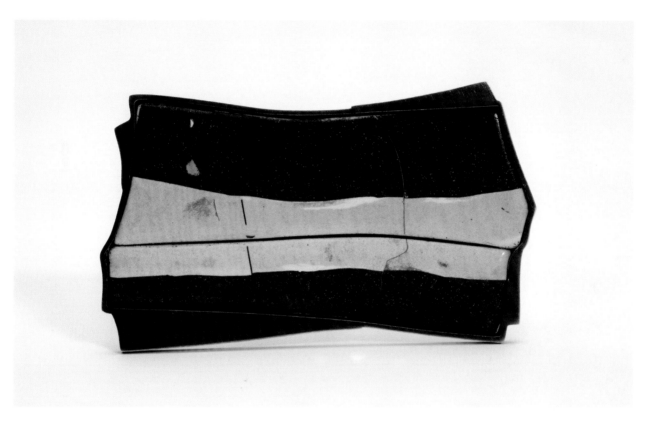

Plate 6 *Black Pivotal 6, Black Fragment* series, 1979
Enamel, copper, silver
1½ × 3¼ in.
Cat. No. 7

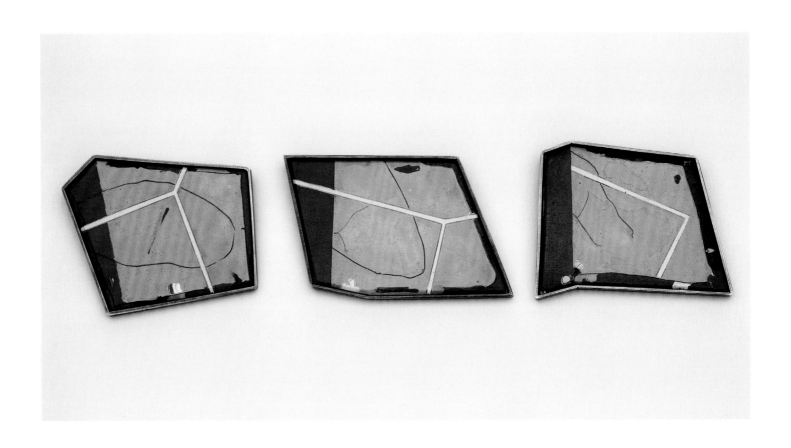

Plate 7 *Red Site* series, 1980
Enamel, copper, silver

Left: *Red Site 3*
1⅞ × 2¼ × ⁵⁄₁₆ in.
Cat. No. 11

Center: *Red Site 2*
1⅝ × 2½ × ¼ in.
Cat. No. 10

Right: *Red Site 1*
1⅞ × 2¼ × ¼ in.
Cat. No. 9

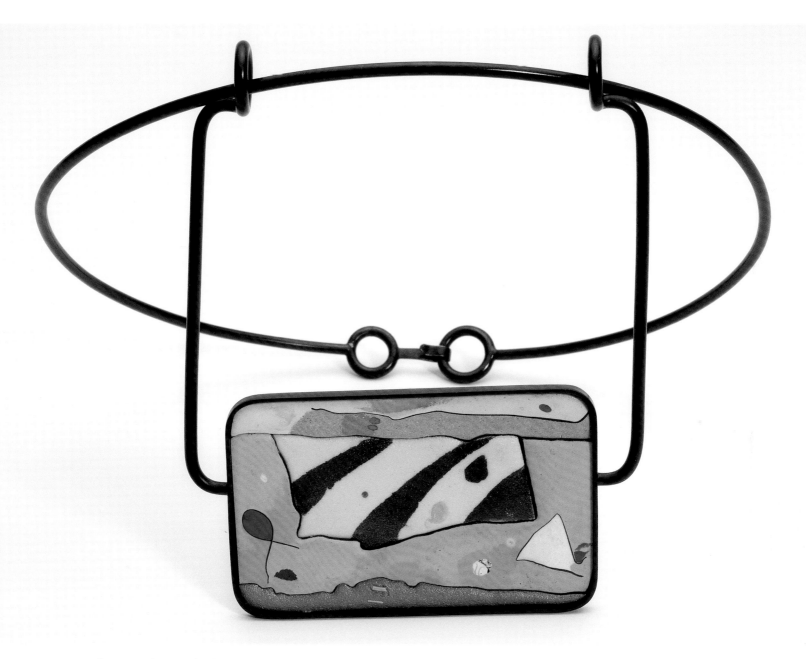

Plate 8 *Coral Tesserae* (neckpiece), 1984
Enamel, copper, silver, black chrome
10⅛ × 6½ × ⅝ in.
Cat. No. 13

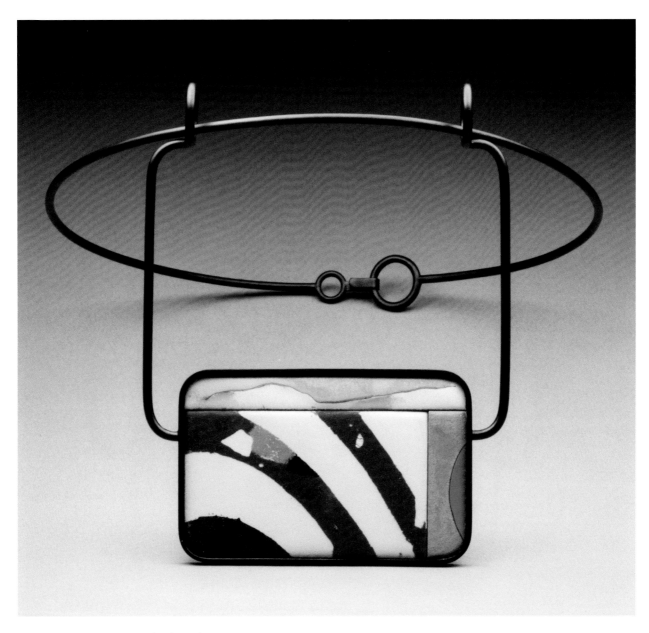

Plate 9 *Delta, Tesserae* series (neckpiece), 1984
Enamel, copper, silver, black chrome
Approx. 9¾ × 6 × ⅜ in.
Cat. No. 14

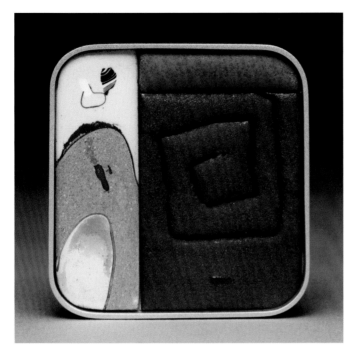

Plate 10 *Blue Spiral*, 1985
Enamel, copper, silver
1¾ × 1¹³⁄₁₆ in.
Cat. No. 15

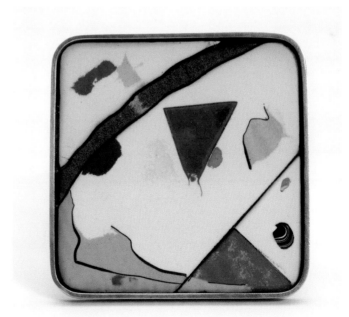

Plate 11 *Appalachian Spring, Tesserae* series, 1984
Enamel, copper, silver
1⅜ × 1⅜ × ¼ in.
Cat. No. 16

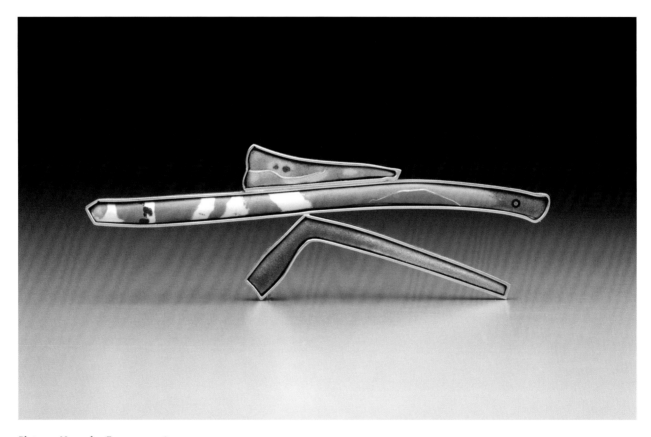

Plate 12 *November Fragment*, 1985
Enamel, copper, silver
1½ × 4½ × ⅜ in.
Cat. No. 17

54 *Jewelry*

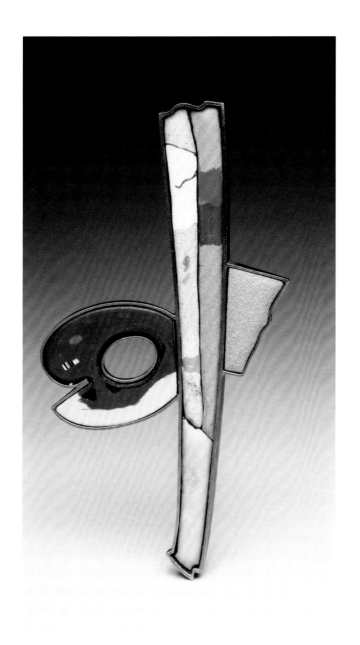

Plate 13 *Coloratura 3*, 1985
Enamel, copper, silver, gold
4 × 1½ × ¼ in.
Cat. No. 18

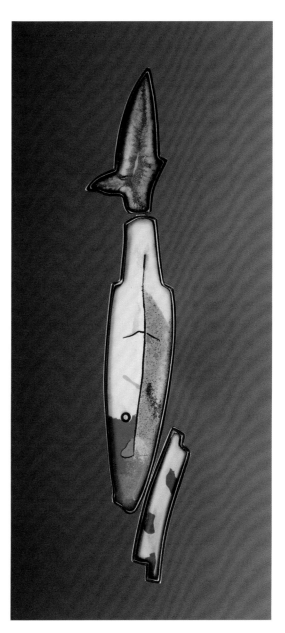

Plate 14 *Totem, Coloratura* series, 1985
Enamel, copper, silver
4⅜ × 1³⁄₁₆ × ¾ in.
Cat. No. 20

Jewelry 55

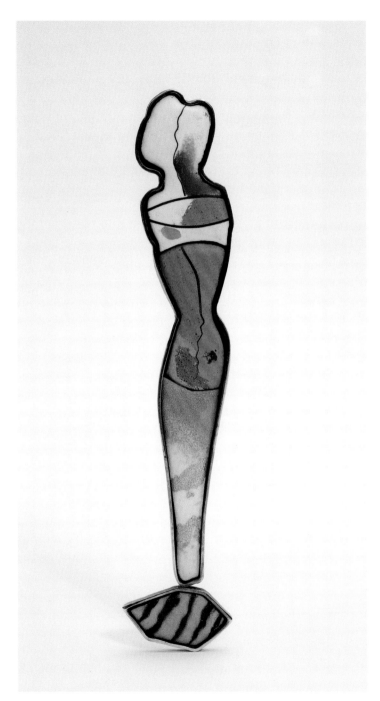

Plate 15 *Body, Bottle and Body* series, 1985
Enamel, copper, gold
4¾ × ¹⁵⁄₁₆ × ⅛ in.
Cat. No. 21

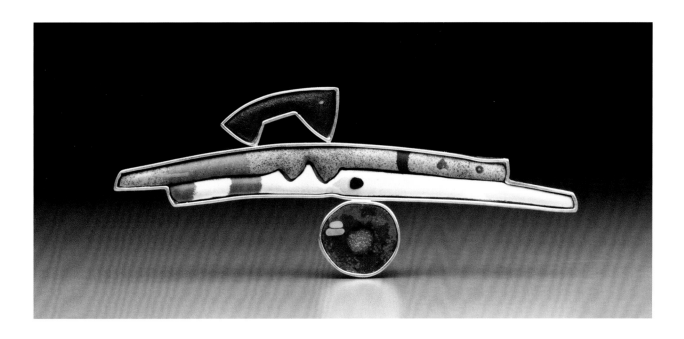

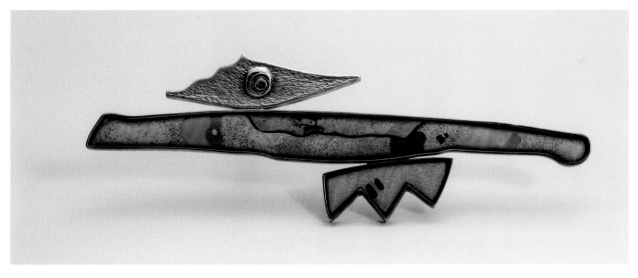

ABOVE
Plate 16 *Deerrun 2*, c. 1985–1986
Enamel, copper, silver
1¹¹⁄₁₆ × 4⁵⁄₁₆ × ¼ in.
Cat. No. 23

BELOW
Plate 17 *Deerrun 14*, c. 1985–1986
Enamel, copper, silver, gold
1¼ × 4¼ × ¼ in.
Cat. No. 26

Jewelry 57

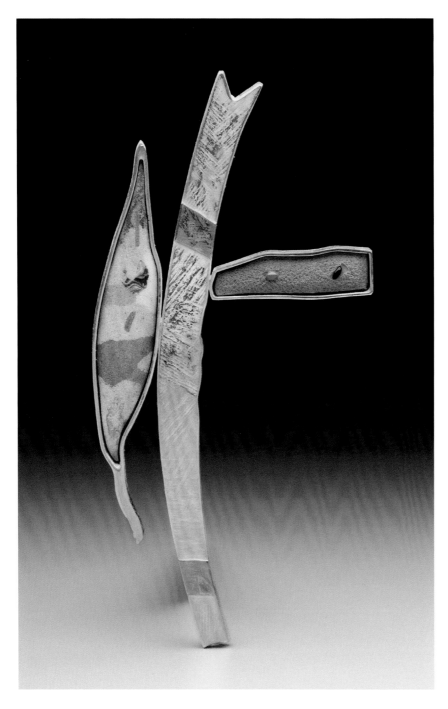

Plate 18 *Calypsos 2*, 1986
Enamel, copper, silver, gold
4½ × 2½ × ½ in.
Cat. No. 28

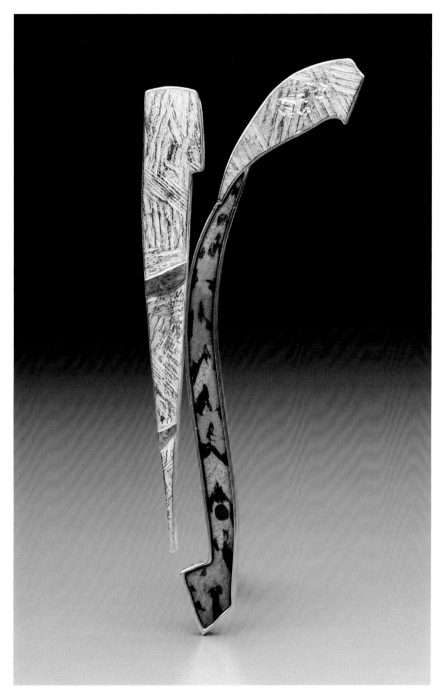

Plate 19 *Calypsos 4*, 1986
Enamel, copper, silver
4½ × 2⅜ × ⅜ in.
Cat. No. 29

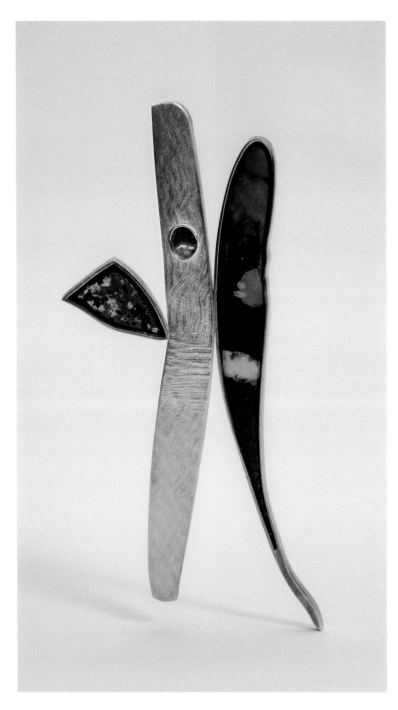

Plate 20 *Aioula 11*, 1988
Enamel, copper, silver, gold
5 × 2½ × ½ in.
Cat. No. 30

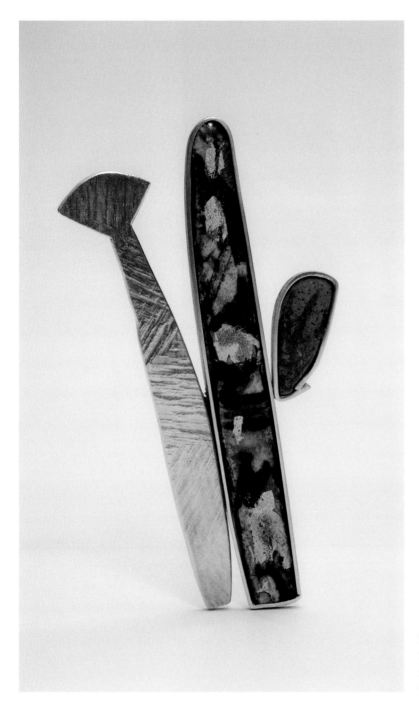

Plate 21 *Aioula 16*, 1988
Enamel, copper, silver, gold
3½ × 2 × ¼ in.
Cat. No. 31

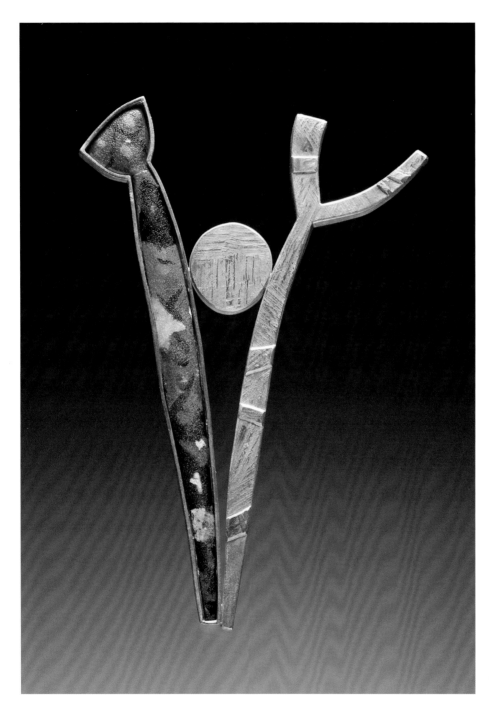

Plate 22 *Aioula 19*, 1988
Enamel, copper, silver, gold
4¾ × 2 × 1⅞ in.
Cat. No. 32

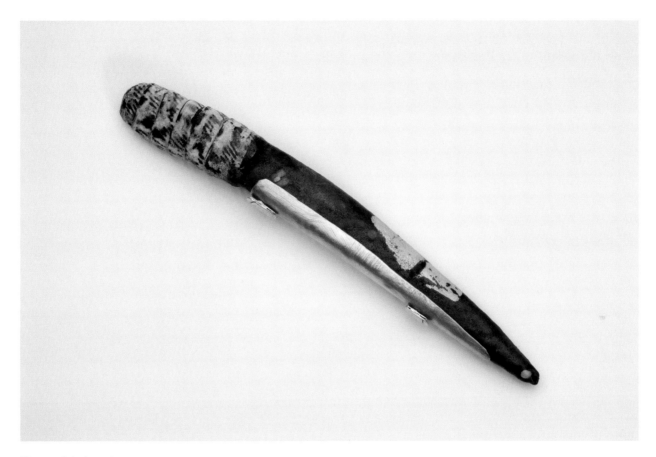

Plate 23 *Priori 3*, 1988
Enamel, copper, gold
5½ × ¾ × ⅝ in.
Cat. No. 34

Jewelry 63

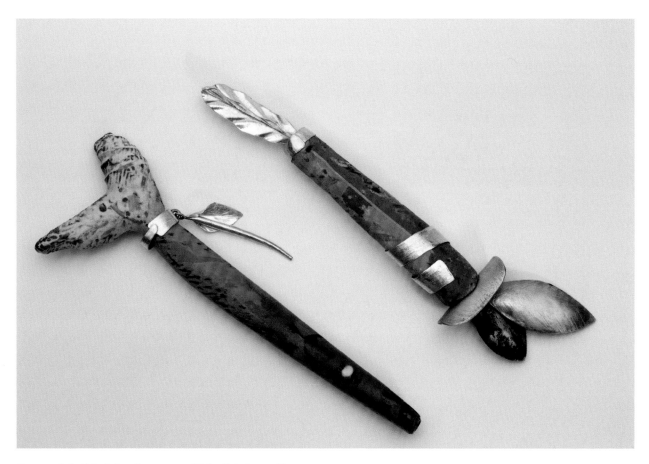

Plate 24 Left: *Priori 16*, 1989
Enamel, copper, gold
4¾ × 3¼ × ½ in.
Cat. No. 37

Right: *Priori 10*, 1988
Enamel, copper, gold
5¼ × 2½ × ½ in.
Cat. No. 36

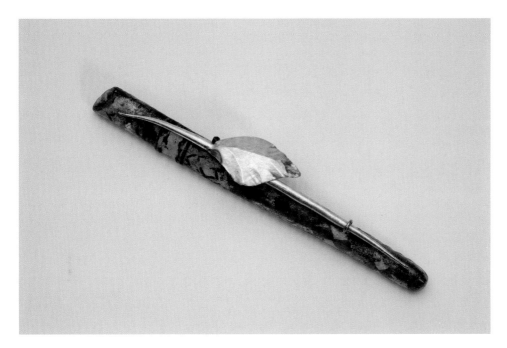

Plate 25 *Priori 17*, 1989
Enamel, copper, gold
4¼ × 1½ × ⅜ in.
Cat. No. 38

Plate 26 *Priori 21*, 1987
Enamel, copper, gold
5¾ × ⅜ × 1 in.
Cat. No. 39

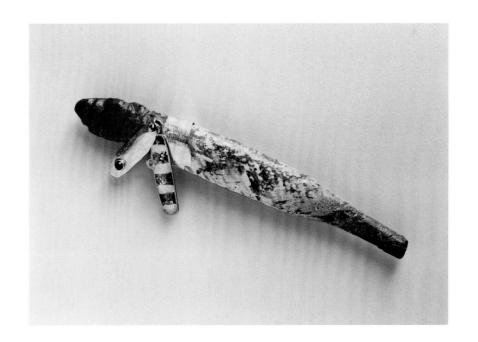

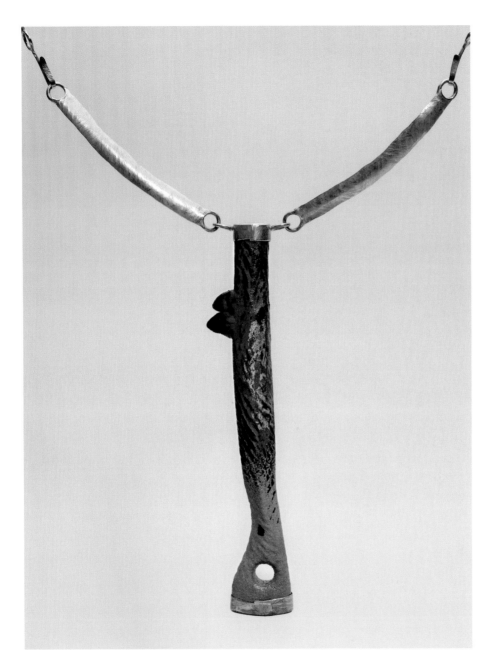

Plate 27 *Uffilia 5* (neckpiece), 1991
Enamel, copper, gold
11¼ × 6½ × ½ in.
Cat. No. 41

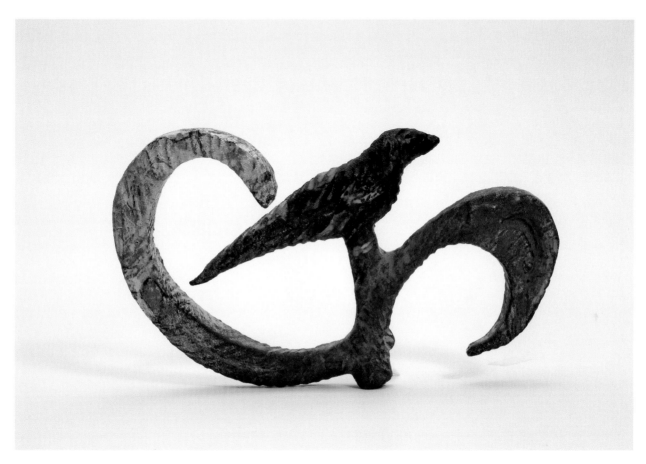

Plate 28 *Black Bird* 3, 1990
Enamel, copper
2⅝ × 4½ × ½ in.
Cat. No. 42

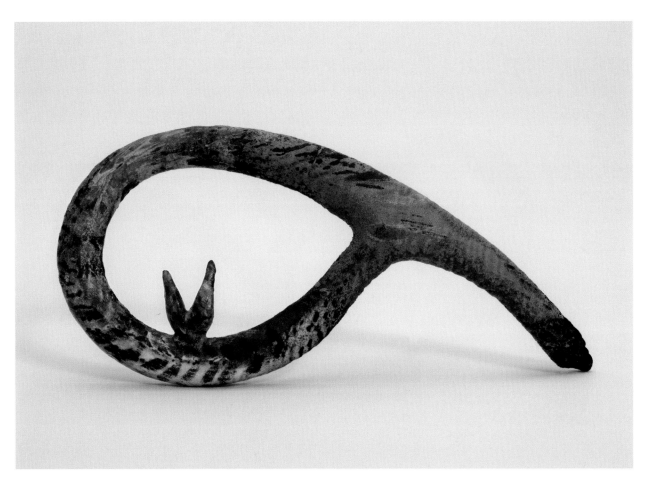

Plate 29 *Chroma 3*, 1991
Enamel, copper
2¼ × 4½ × ½ in.
Cat. No. 43

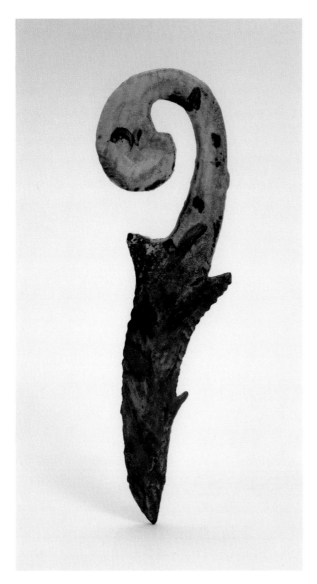

Plate 30 *Rocaille 6*, 1991
Enamel, copper
5⅛ × 1½ × ¼ in.
Cat. No. 45

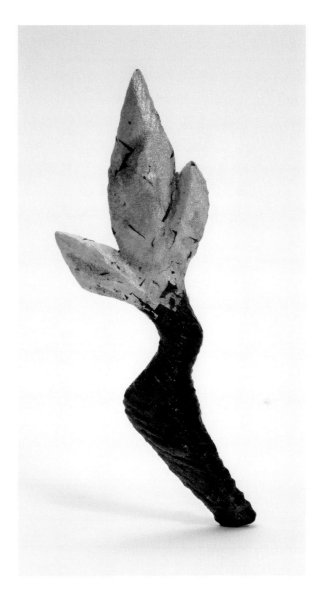

Plate 31 *Rocaille 9*, 1991
Enamel, copper
4½ × 1⅝ × ⅜ in.
Cat. No. 46

Jewelry 69

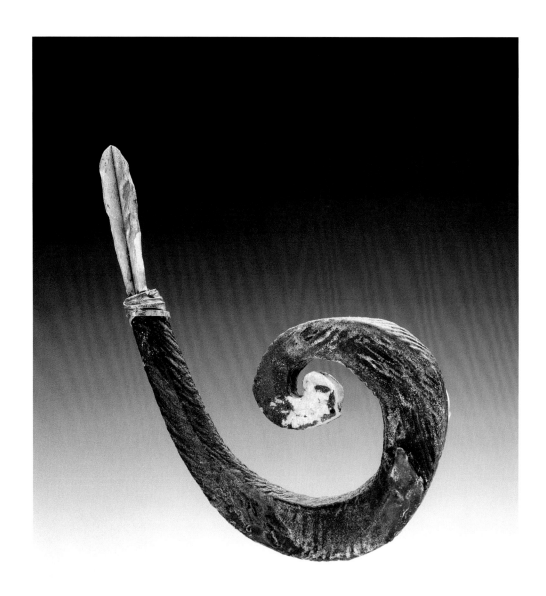

Plate 32 *Rocaille 12*, 1991
Enamel, copper, gold
4¼ × 3½ × ⅝ in.
Cat. No. 47

70 *Jewelry*

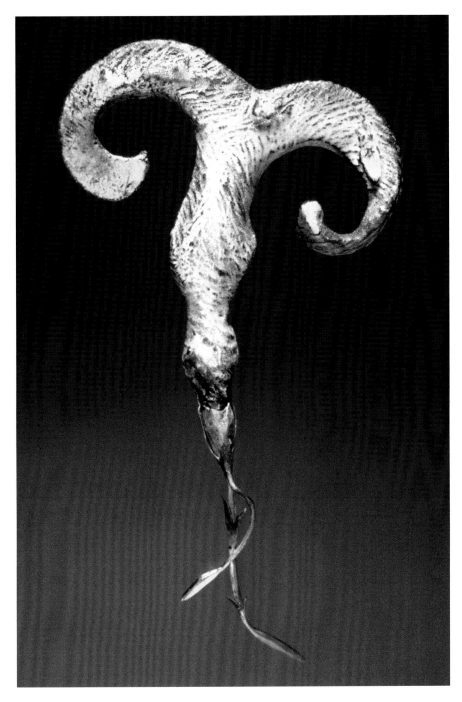

Plate 33 *Rocaille 14*, 1992
Enamel, copper, gold
6 × 2¼ × ½ in.
Cat. No. 48

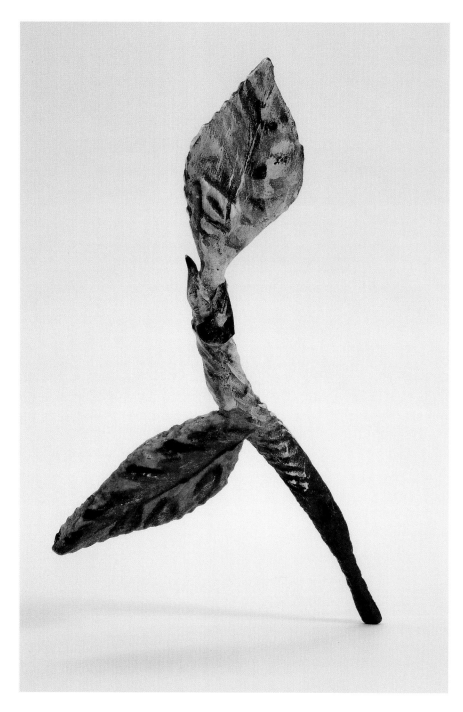

Plate 34 *Rocaille 19*, 1992
Enamel, copper
5 × 3½ × ½ in.
Cat. No. 49

72 *Jewelry*

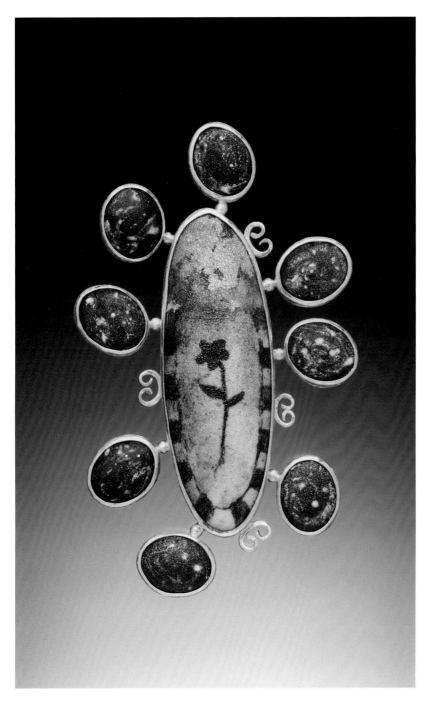

Plate 35 *Jurjani 4*, 1997
Enamel, copper, gold
2⅞ × 1⅞ × ⅜ in.
Cat. No. 52

Jewelry 73

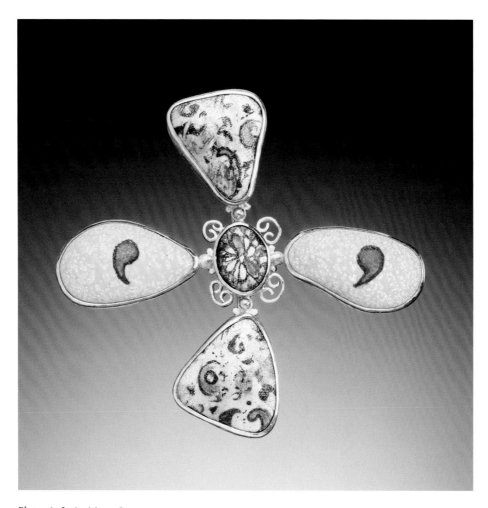

Plate 36 *Jurjani 6*, 1998
Enamel, copper, gold
2⅜ × 2½ × ⅜ in.
Cat. No. 53

74 *Jewelry*

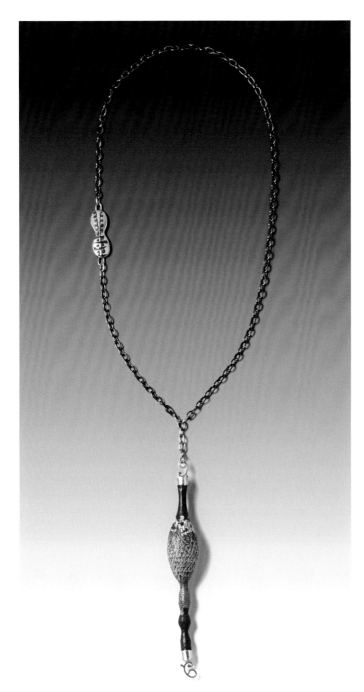

Plate 37 *Jurjani 7* (neckpiece), c. 2000–2002
Enamel, copper, silver, gold
Length: 22¼ in.
Cat. No. 54

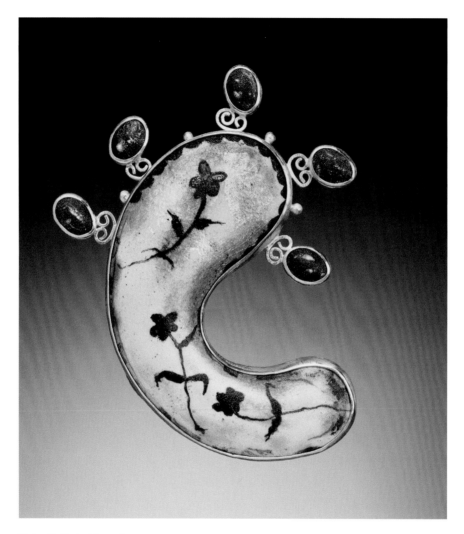

Plate 38 *Jurjani 8*, 1998
Enamel, copper, gold, silver
2 × 3 in.
Cat. No. 55

76 *Jewelry*

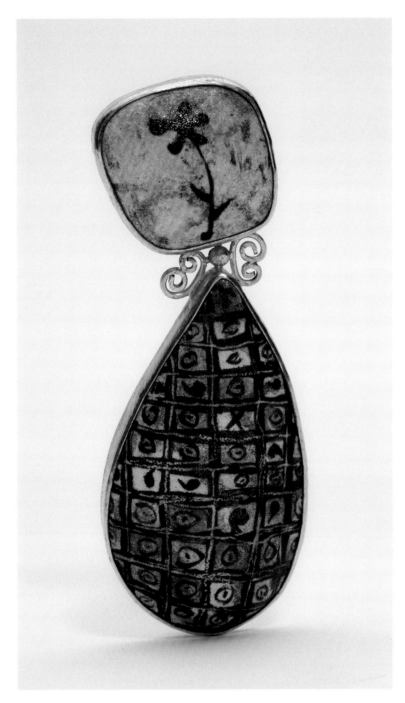

Plate 39 *Composed Garden 1*, 1999
Enamel, copper, gold
2⅝ × 1 × ⅝ in.
Cat. No. 57

Jewelry 77

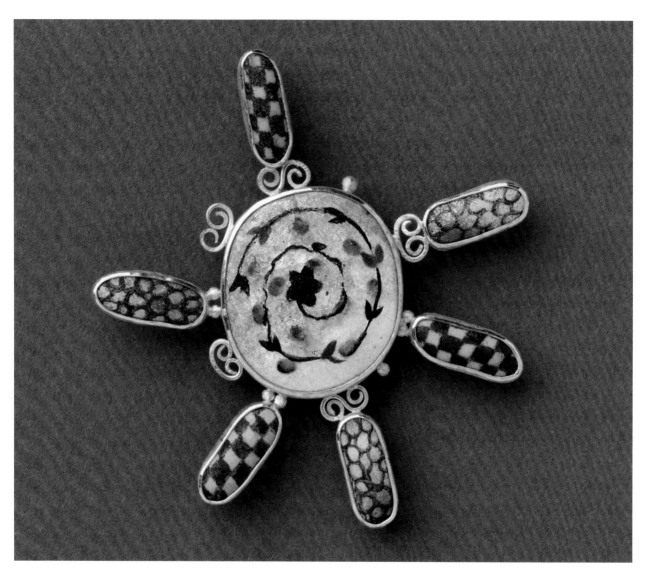

Plate 40 *Composed Garden 3*, 1999
Enamel, copper, gold
2¼ × 2¼ × ½ in.
Cat. No. 59

78 *Jewelry*

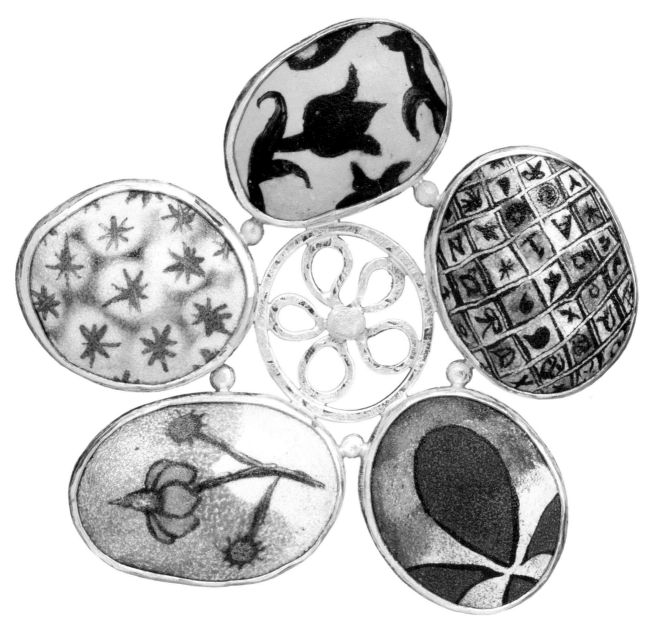

Plate 41 *Composed Garden 6*, 1999
Enamel, copper, gold
3 × 3 × ⅜ in.
Cat. No. 60

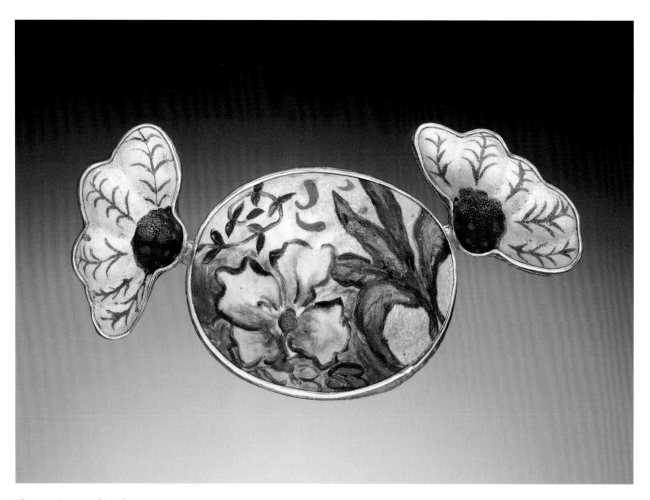

Plate 42 *Composed Garden 12*, 1999
Enamel, copper, gold
1½ × 2 × ⅜ in.
Cat. No. 61

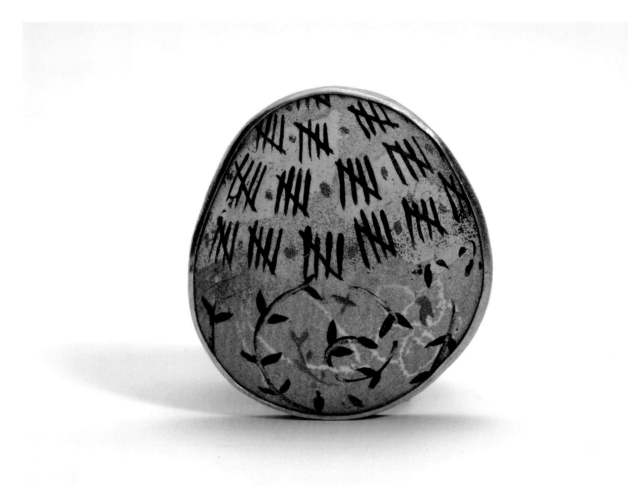

Plate 43 *Melancholia*, 1999
Enamel, copper, gold, silver
1¾ × 1⁹⁄₁₆ × ½ in.
Cat. No. 62

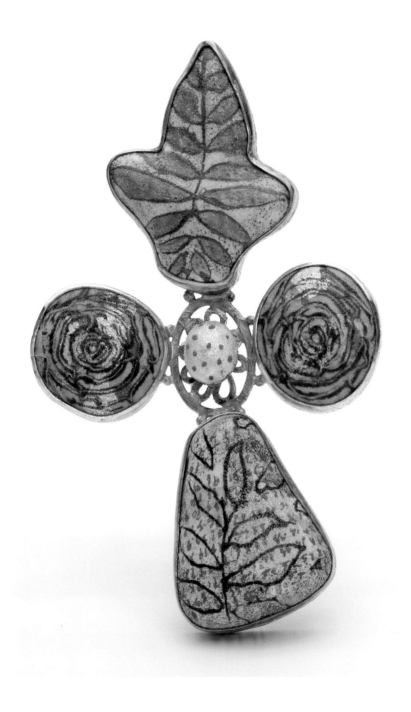

Plate 44 *Star-Eyed Brooch*, 1999
Enamel, copper, gold
3 × 1⅞ × ½ in.
Cat. No. 63

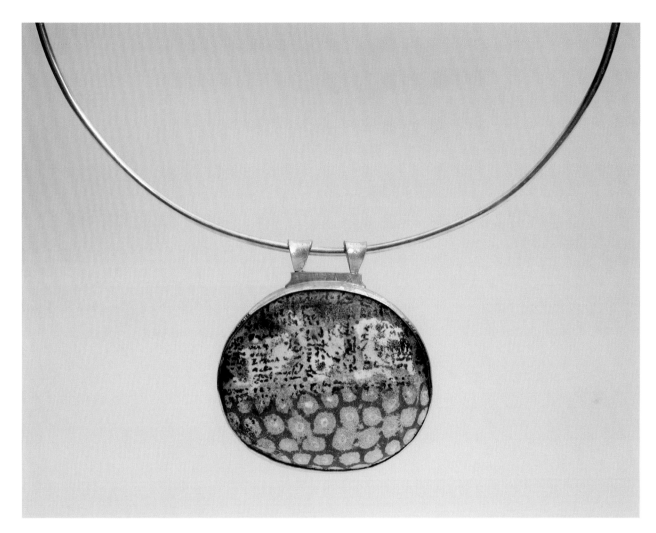

Plate 45 *Chadour* (neckpiece), 2000
Enamel, copper, gold
7⅜ × 5⅜ × ½ in.
Cat. No. 64

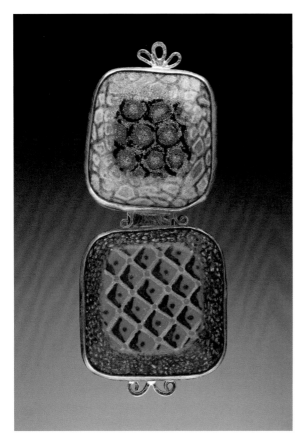

Plate 46 *Chadour 6*, 2000
Enamel, copper, gold
2¼ × 1 × ½ in.
Cat. No. 65

Plate 47 *Chadour 9*, 2000
Gold, copper, enamel
2⅝ × 1 × ⅝ in.
Cat. No. 66

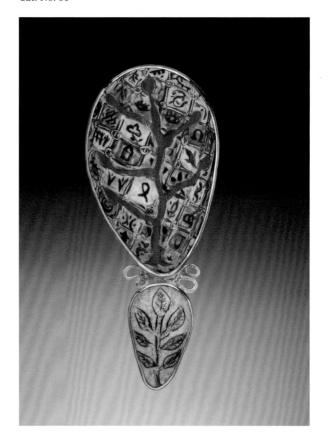

84 *Jewelry*

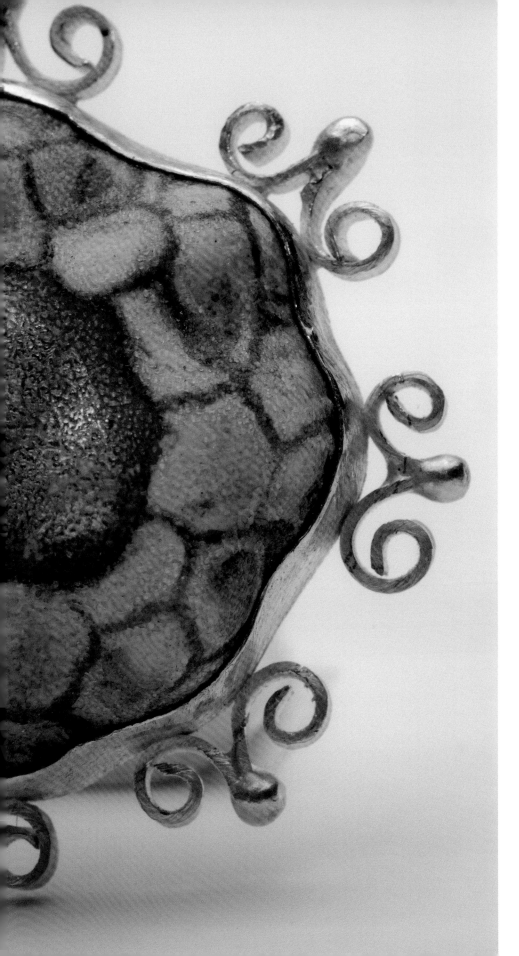
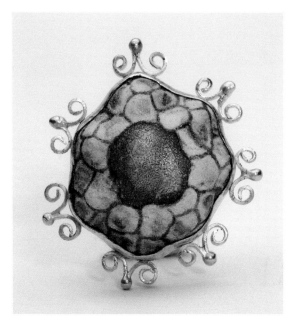

Plate 48 *Chadour 17*, 2001
Enamel, copper, gold
⅜ × 1 × 1 in.
Cat. No. 67

Jewelry 85

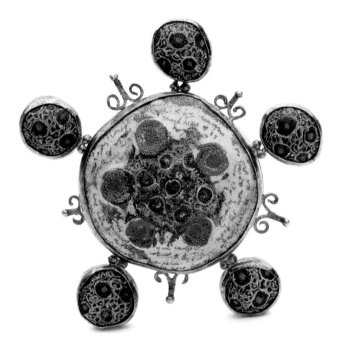

Plate 49 *Lumen 1*, 2000
Enamel, copper, gold
Height: ⅝ in., diameter: 2½ in.
Cat. No. 68

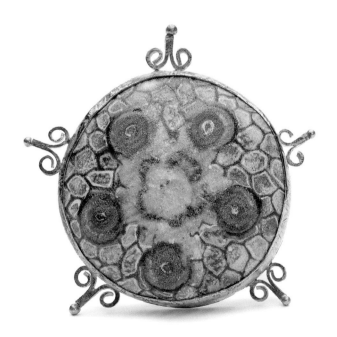

Plate 50 *Lumen 4*, 2000
Enamel, copper, gold
Height: ⅝ in., diameter: 2⅛ in.
Cat. No. 69

86 *Jewelry*

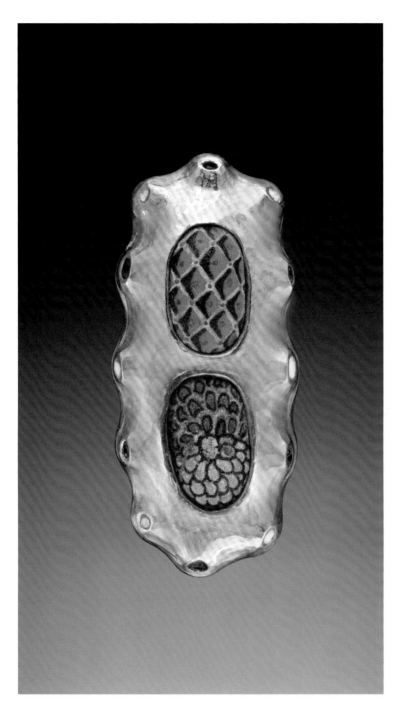

Plate 51 *Safavid 2*, 2002
Enamel, copper, gold
2 × ⅞ × ⅜ in.
Cat. No. 71

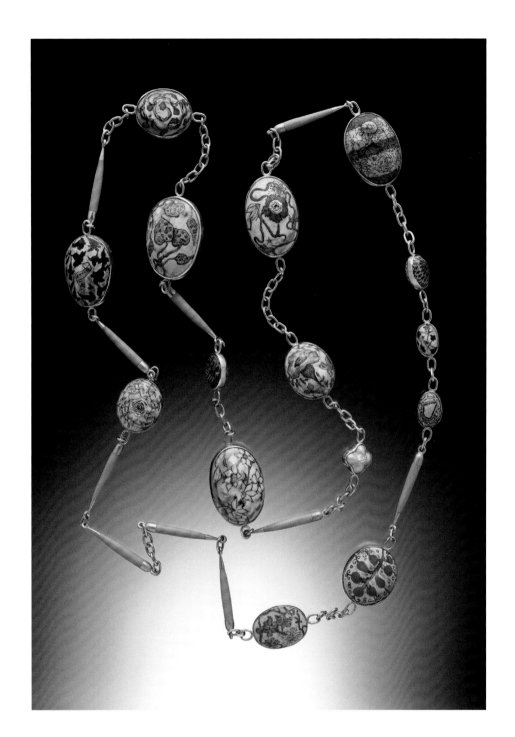

88 *Jewelry*

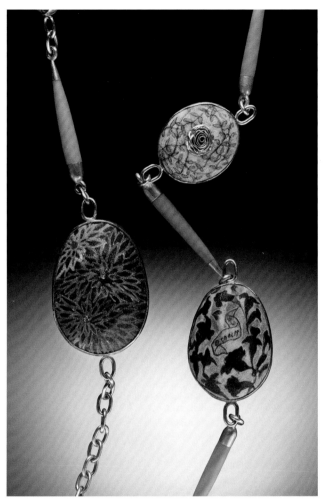

Plate 52 *Florilegium* (neckpiece), 2002
Enamel, copper, gold
Length: 42 in.
Cat. No. 73

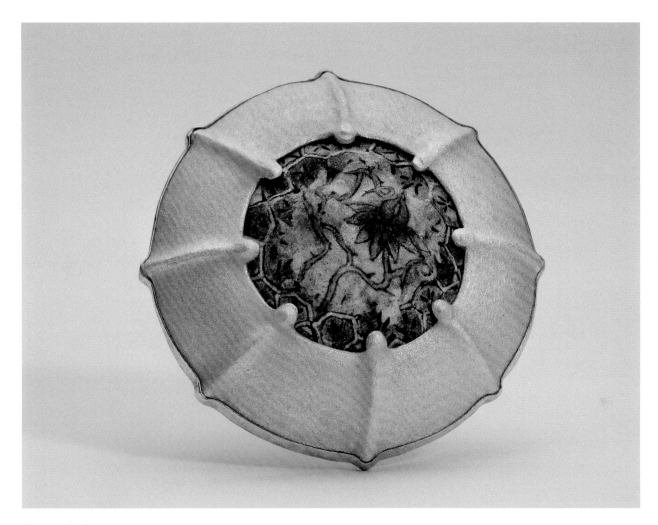

Plate 53 *Florilegium 1*, 2002
Enamel, copper, gold
Height: ½ in., diameter: 2¼ in.
Cat. No. 74

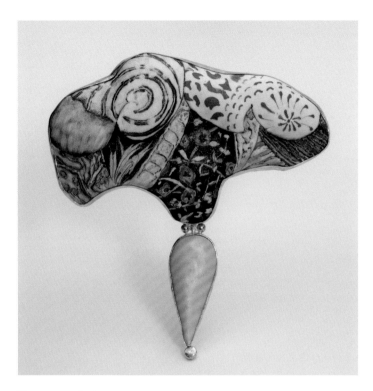

Plate 54 *Florilegium 2*, 2002–2003
Enamel, copper, gold
4 × 3 × ½ in.
Cat. No. 75

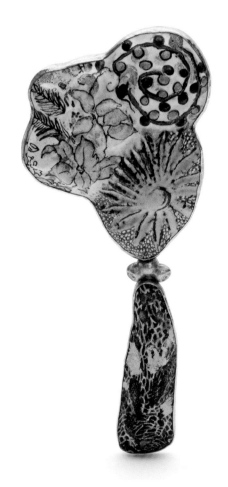

Plate 55 *Florilegium 3*, 2003
Enamel, copper, gold
5 × 2 × ½ in.
Cat. No. 76

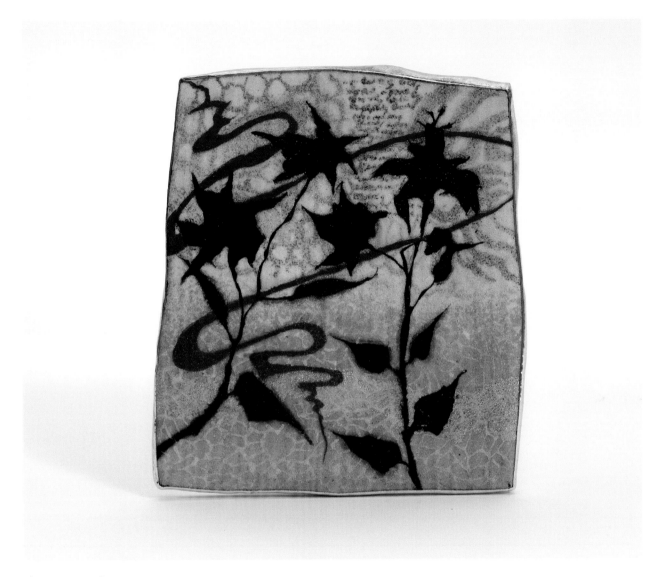

Plate 56 *Mosaic Scenarios 1*, 2005
Enamel, copper, gold
2⅜ × 2⅛ × 3/16 in.
Cat. No. 77

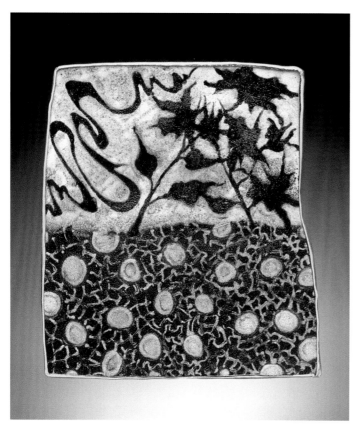

Plate 57 *Mosaic Scenarios 4*, 2005
Enamel, copper, gold
2⅜ × 2⅛ × ⅛ in.
Cat. No. 78

Plate 58 *Mosaic Scenarios 5*, 2005
Enamel, copper, gold
Height: 3/16 in., diameter: 2 in.
Cat. No. 79

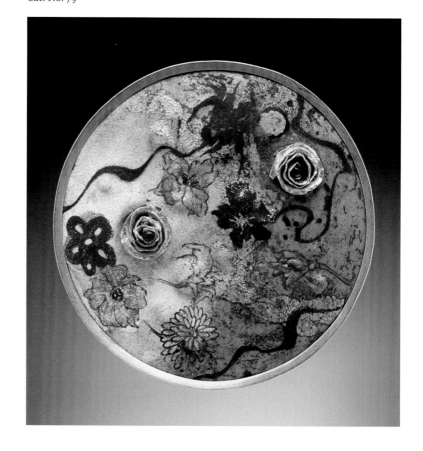

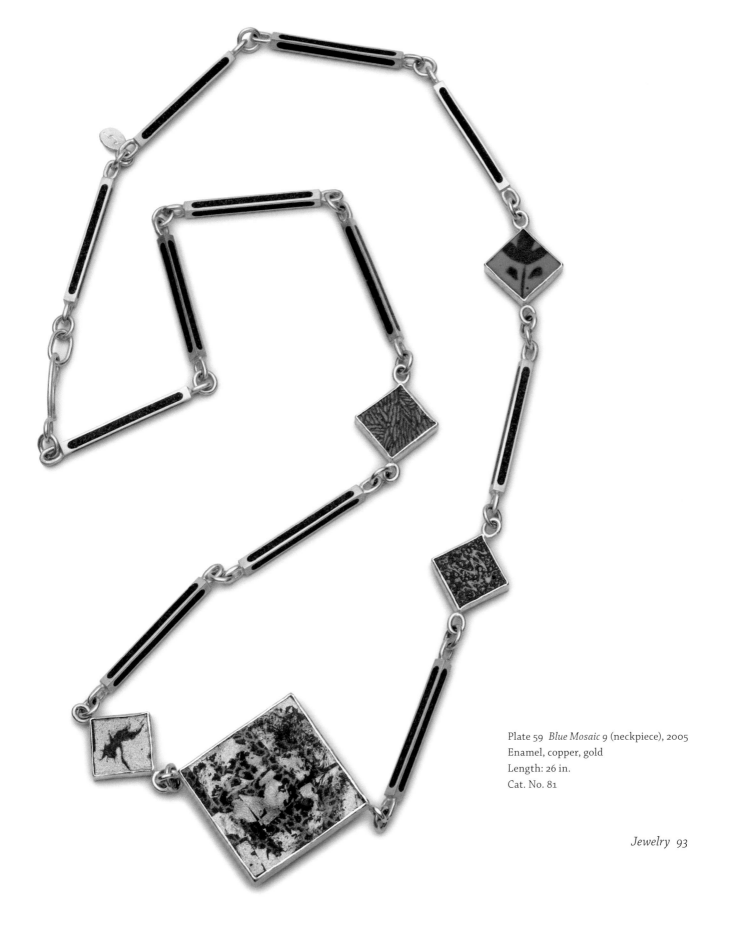

Plate 59 *Blue Mosaic 9* (neckpiece), 2005
Enamel, copper, gold
Length: 26 in.
Cat. No. 81

Jewelry 93

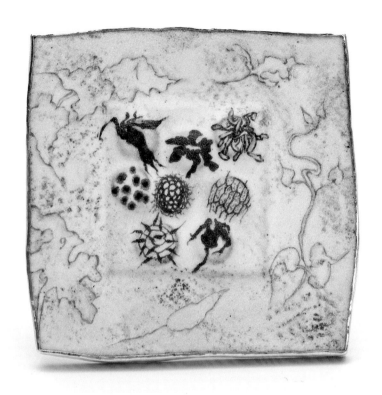

Plate 60 *Mosaic Scenarios 10*, 2005
Enamel, copper, gold
1⅞ × 1⅞ × ³⁄₁₆ in.
Cat. No. 83

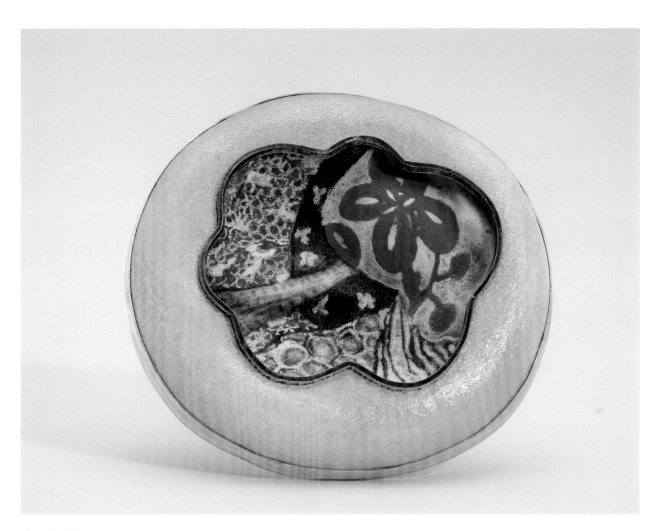

Plate 61 *Polonaise 1*, 2004
Enamel, copper, gold
2⅛ × 2¼ × ⅜ in.
Cat. No. 84

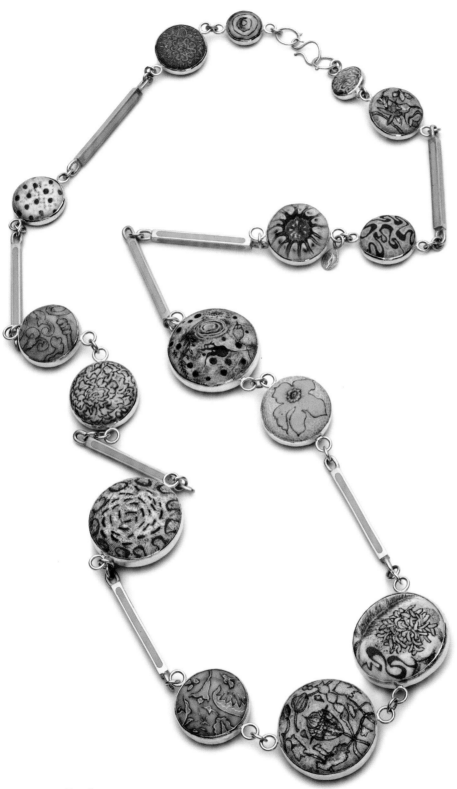

Plate 62 *Urban Traces 1* (neckpiece), 2005
Enamel, copper, gold
Length: 28½ in.
Cat. No. 86

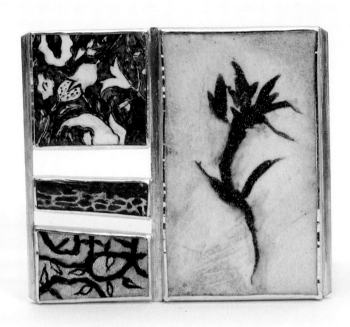

Plate 63 *Urban Traces 1*, 2006
Enamel, copper, gold
1½ × 1¾ × ⅛ in.
Cat. No. 87

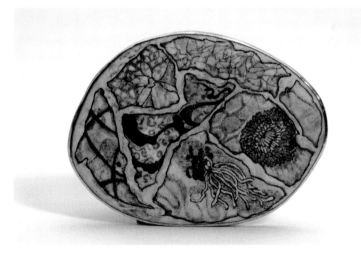

Plate 64 *Urban Traces 2*, 2006
Enamel, copper, gold
1¾ × 2⅜ × 3/16 in.
Cat. No. 88

Jewelry 97

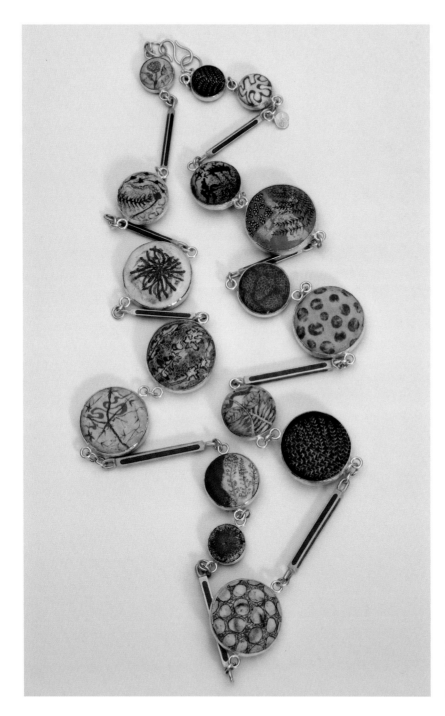

Plate 65 *Urban Traces 4* (neckpiece), 2006
Enamel, copper, gold
Length: 36 in.
Cat. No. 89

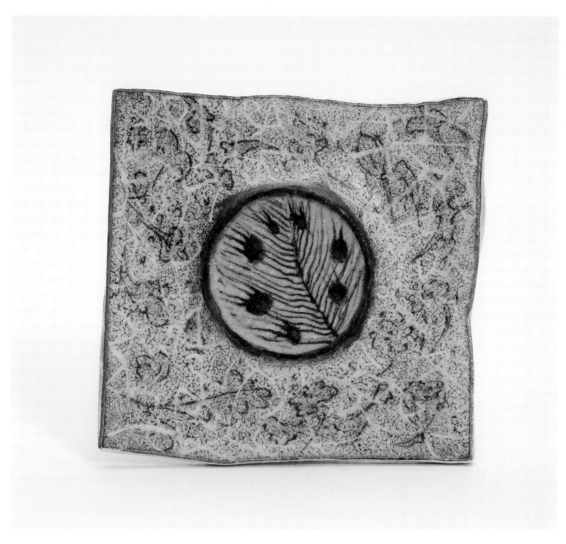

Plate 66 *Urban Traces* 7, 2006
Enamel, copper, gold
2 × 2¼ × 3/16 in.
Cat. No. 90

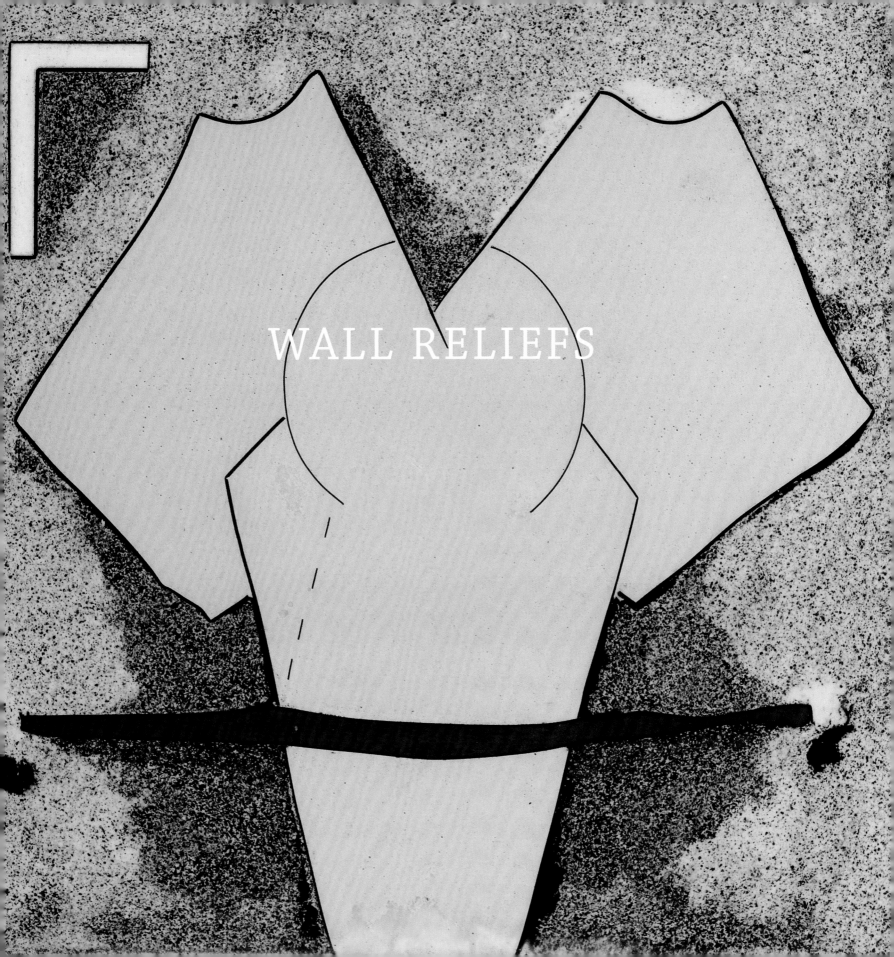

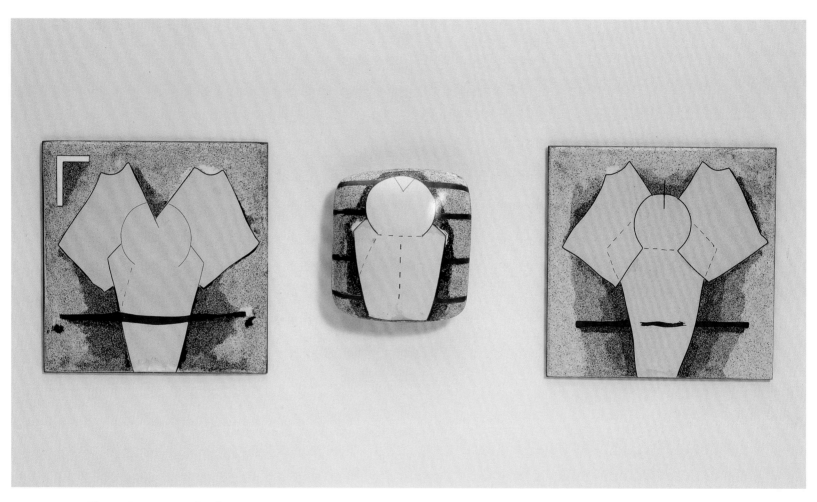

Plate 67 *Pattern* triptych, *White* series, 1979
Enamel, copper
Overall: 10⅛ × 12 × 1½ in.
Cat. No. 91

102 *Wall Reliefs*

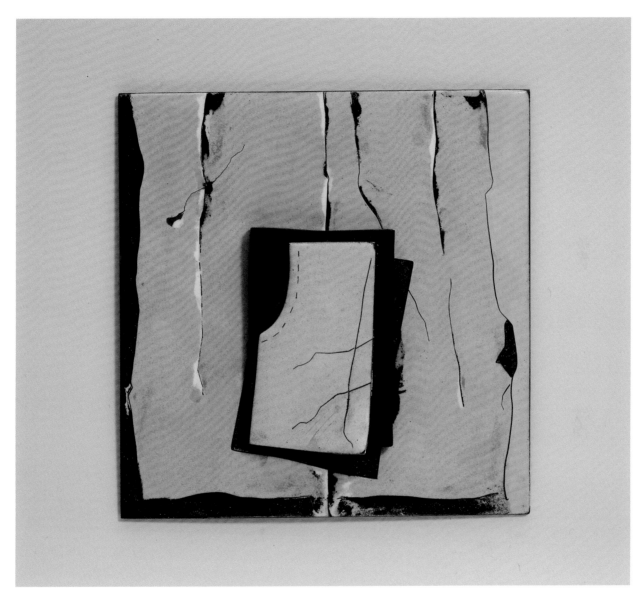

Plate 68 *Pattern Fragment, Black Fragment* series, 1980
Enamel, copper, silver
Overall: 5 × 5 in.
Cat. No. 92

Wall Reliefs 103

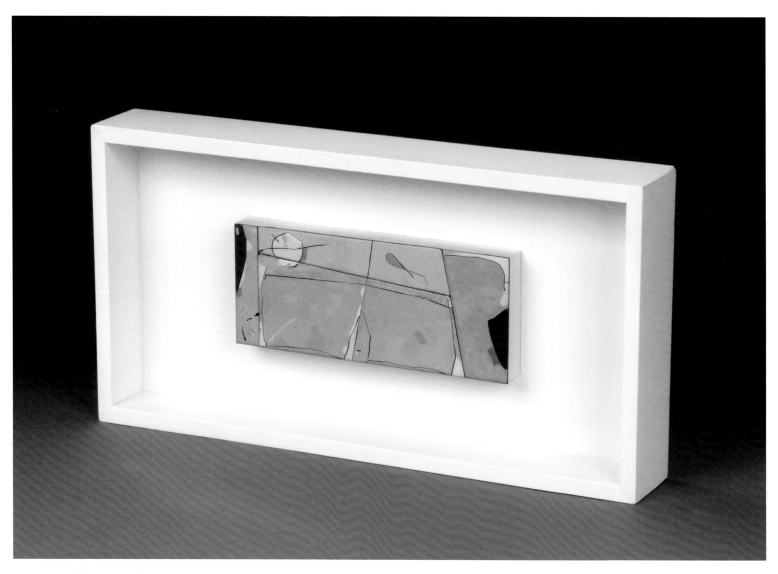

Plate 69 *Spiral Tesserae*, 1983
Enamel, copper, paint, wood
7 × 14 × 2 in. (framed)
Cat. No. 93

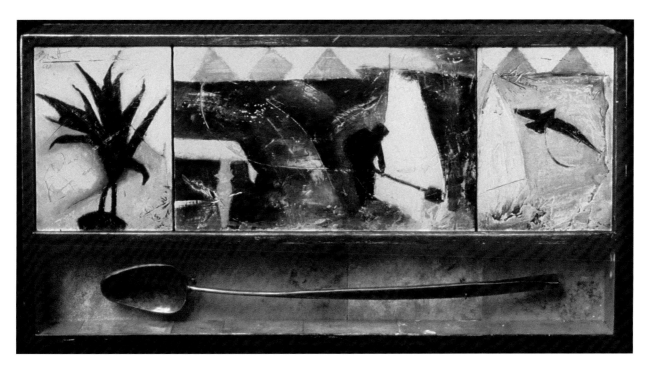

Plate 70 *End of the Table*, 1991
Oil and polymer on panel, forged bronze
18 × 30 × 5 in.
Cat. No. 96

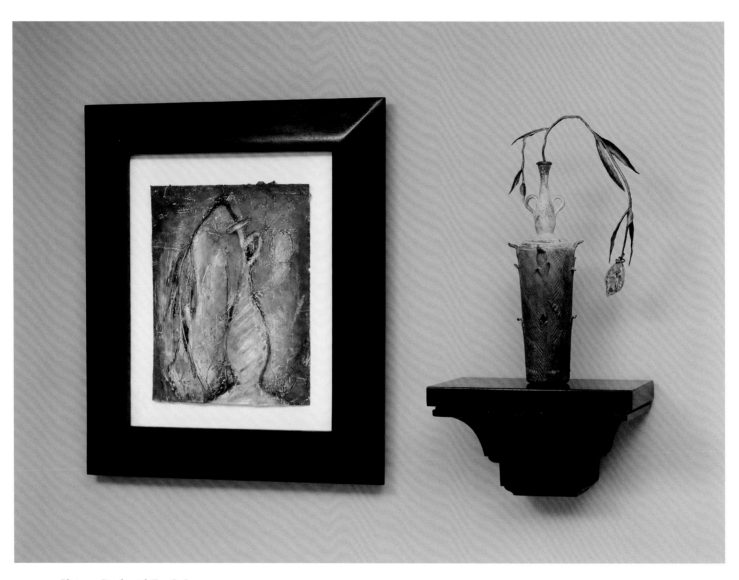

Plate 71 *Bottle with Two References 10*, 1991
Mixed media
24 × 17 in. overall
Cat. No. 97

106 *Wall Reliefs*

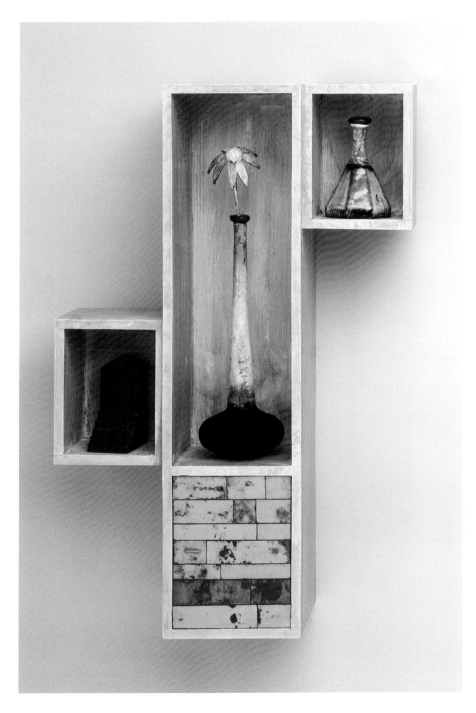

Plate 72 *Red Steps*, 1998
Polymer, oil, encaustic, wood, enamel, copper
18 × 12½ × 4½ in.
Cat. No. 98

Wall Reliefs

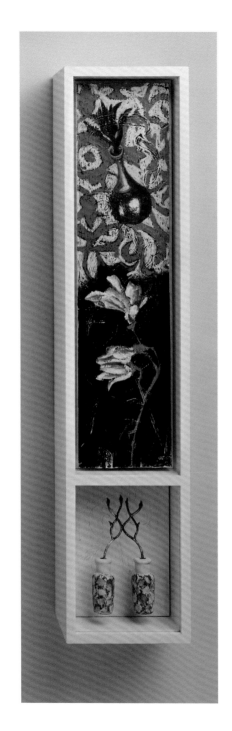
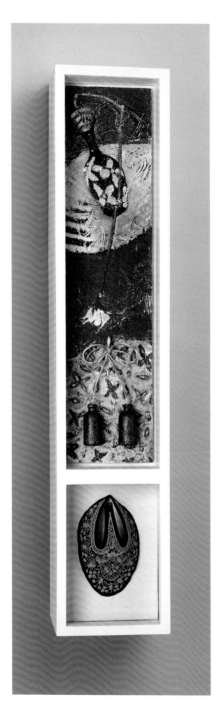

Plate 73 Left: *Making Hybrids 1*, 1999
Polymer, encaustic, oil, wood, enamel, copper
30½ × 6½ × 5½ in.
Cat. No. 99

Right: *Making Hybrids, 2*, 1999
Polymer, encaustic, oil, wood, enamel, copper, embroidered textile
30½ × 6½ × 5½ in.
Cat. No. 100

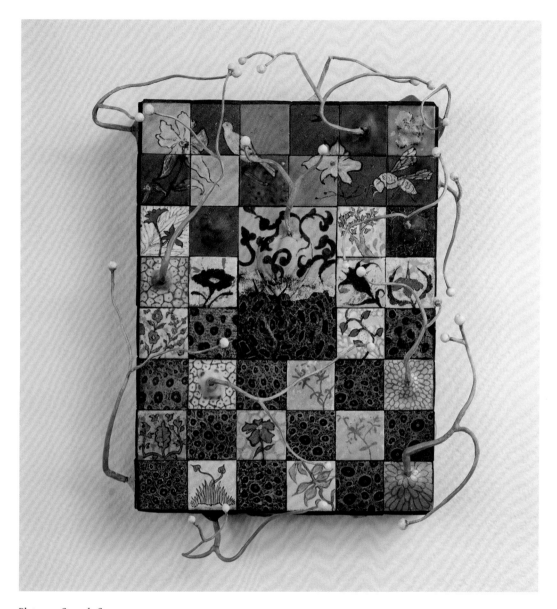

Plate 74 *Coup de fleur*, 2000
Enamel, copper, wood
10 × 8½ in.
Cat. No. 101

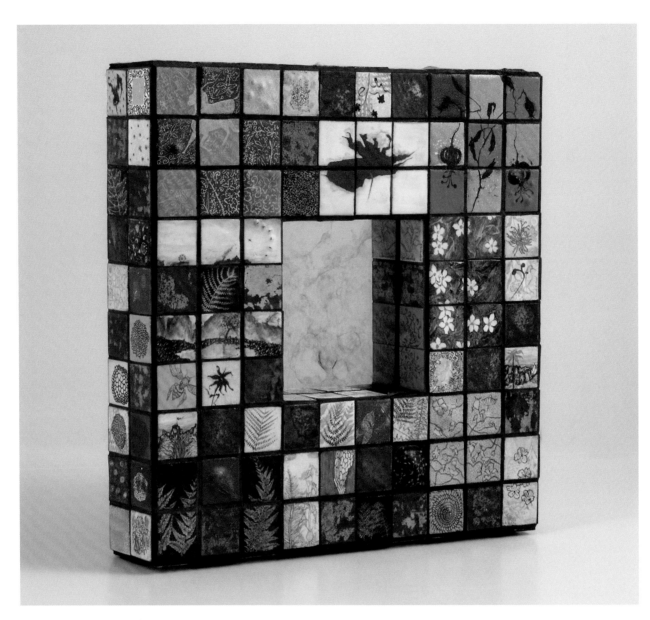

Plate 75 *Woodland Spectacle*, 2006
Enamel, copper, wood, looking glass
10⅞ × 11⅞ × 2⅛ in.
Cat. No. 103

PAINTINGS & DRAWINGS

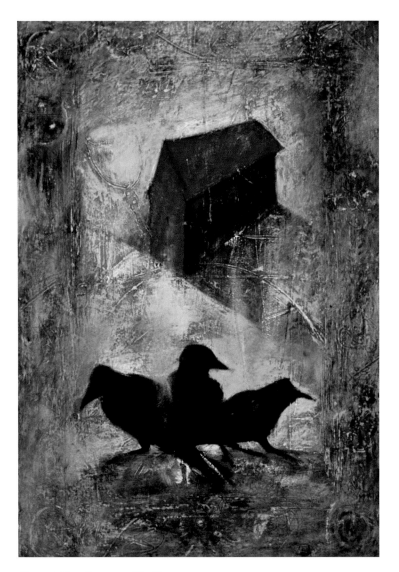
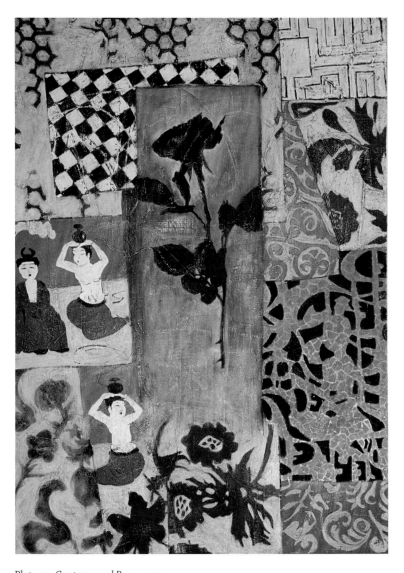

Plate 76 *Three Ravens and Red Barn*, 1994
Oil, polymer, and encaustic on paper
42 × 30 in.
Cat. No. 104

Plate 77 *Gautama and Rose*, 1997
Oil and polymer on paper
50 × 41 in.
Cat. No. 105

112 *Paintings & Drawings*

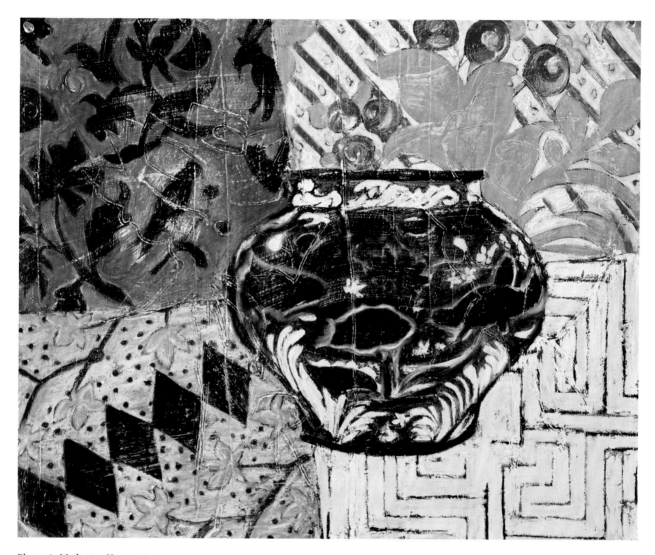

Plate 78 *Mediating Use*, 1998
Oil and polymer on paper
20 × 24 in.
Cat. No. 107

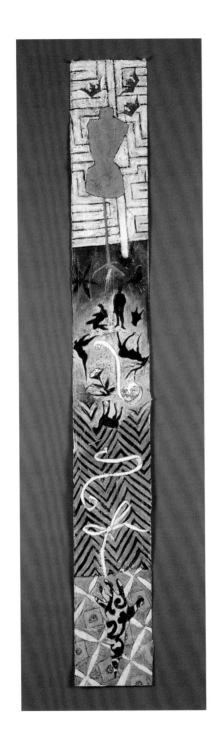
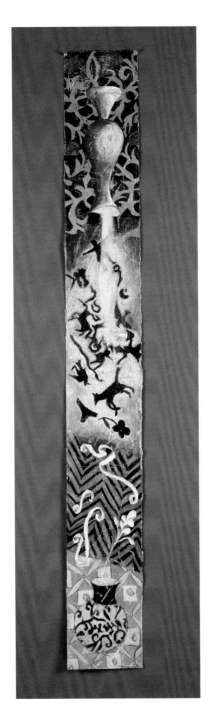

LEFT
Plate 79 *Domestic Rescue*, 1998
Oil and polymer on paper
72 × 9 in.
Cat. No. 108

RIGHT
Plate 80 *Sentimental Signals*, 1998
Oil and polymer on paper
72 × 9 in.
Cat. No. 109

114 *Paintings & Drawings*

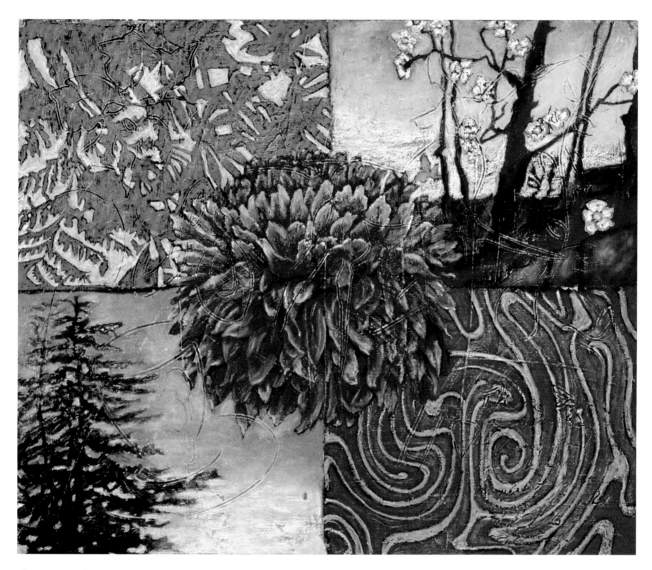

Plate 81 *Hiroshige, Vincent, and Chrysanthemum*, 2004
Oil, encaustic, and polymer on paper
25 × 30 in.
Cat. No. 111

Paintings & Drawings 115

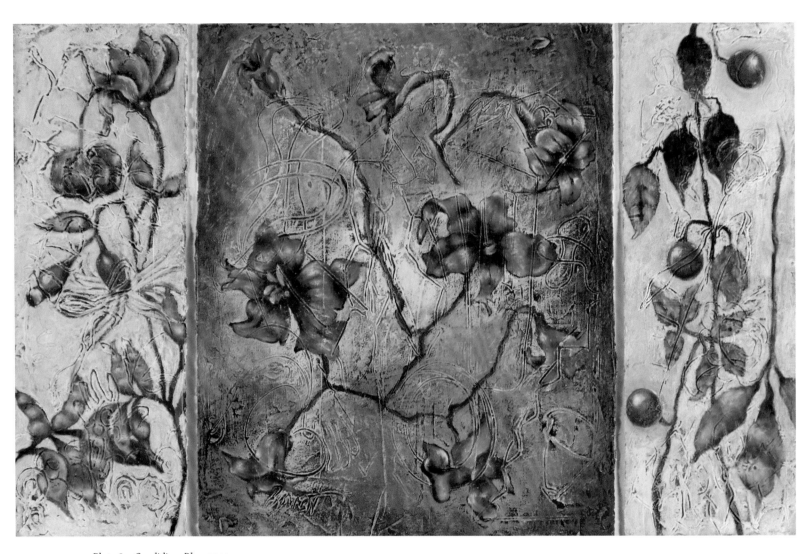

Plate 82 *Candidium Blue*, 2003
Oil and polymer on paper
30⅞ × 45⅜ in.
Cat. No. 114

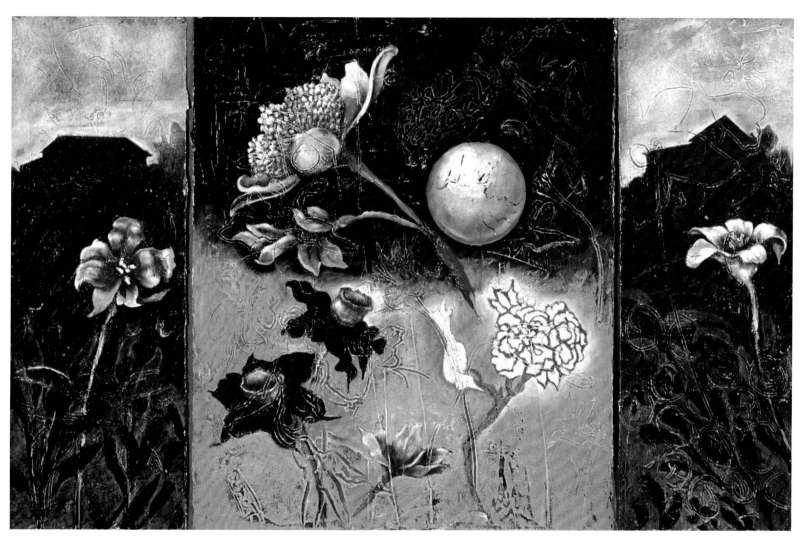

Plate 83 *Le Soir Frieze*, 2004
Oil and polymer on paper
25½ × 40 in.
Cat. No. 115

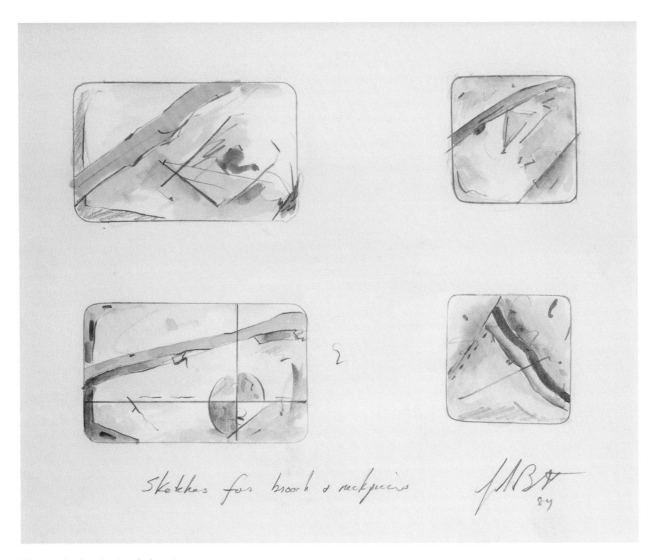

Plate 84 Studies for *Appalachian Spring*, 1984
Graphite and watercolor on paper
16¼ × 17½ × ¾ in. framed
Cat. No. 116

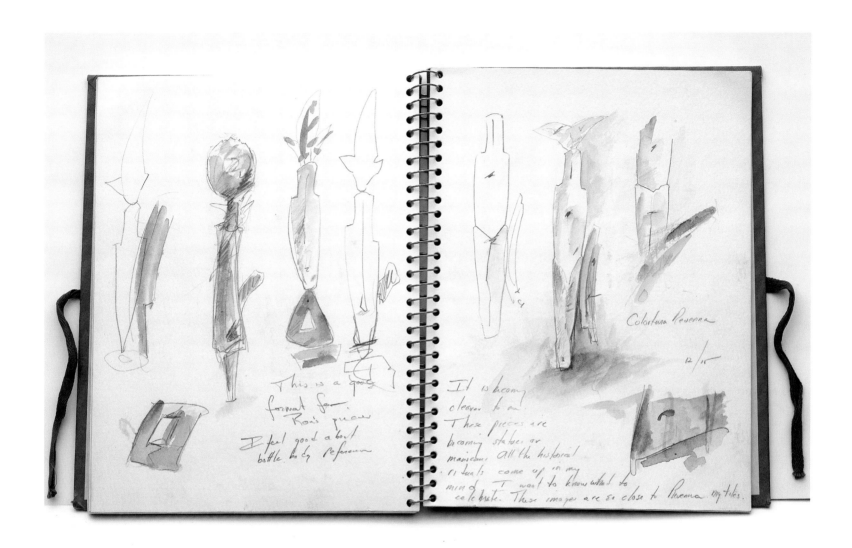

Plate 85 Studies for *Bottle and Body* series (sketchbook), 1985
Graphite and watercolor on wove paper
7⅜ × 11¾ in.
Cat. No. 117

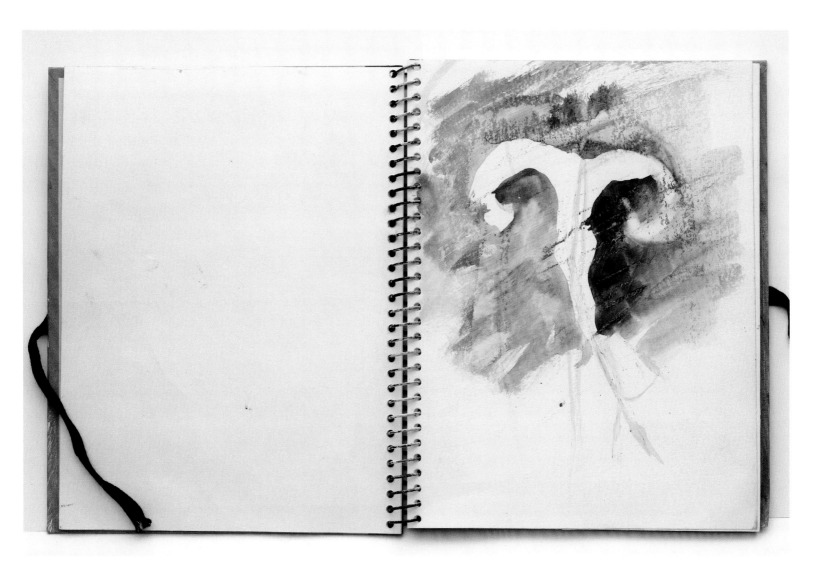

Plate 86 Study for *Rocaille* (sketchbook), c. 1991–1992
Watercolor and gouache on wove paper
7⅜ × 5⅝ in.
Cat. No. 118

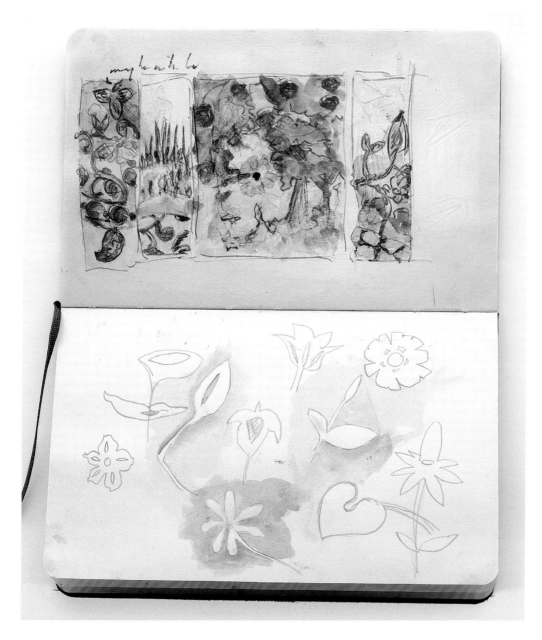

Plate 87 Landscape study (sketchbook), 2004
Graphite, watercolor, gouache on wove paper
10⅜ × 8¼ in.
Cat. No. 119

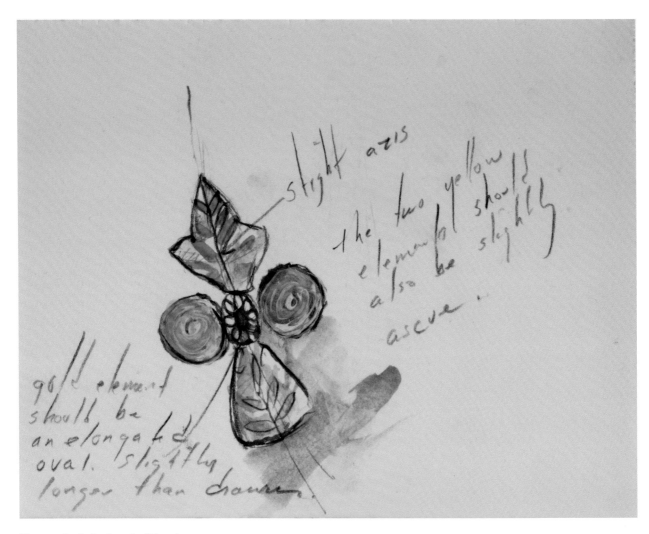

Plate 88 Study for *Star-Eyed Brooch*
Graphite and watercolor on wove paper
5 × 6½ in.
Cat. No. 120

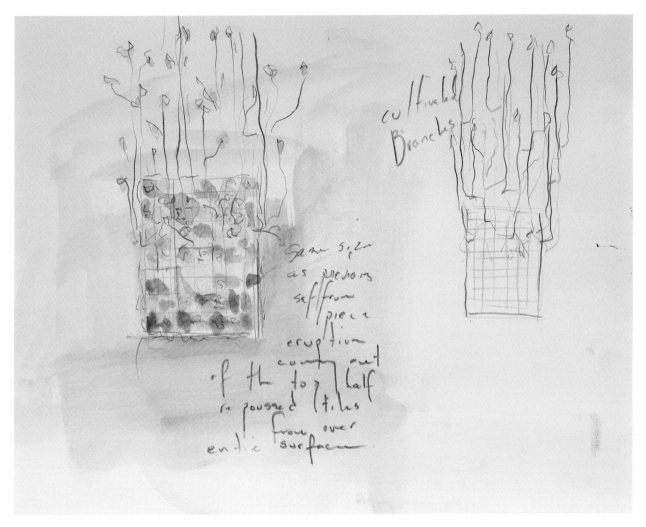

Plate 89 Study for flowered wall decoration, c. 2000
Graphite, colored pencil, watercolor, and gouache on wove paper
9 × 12⅛ in.
Cat. No. 121

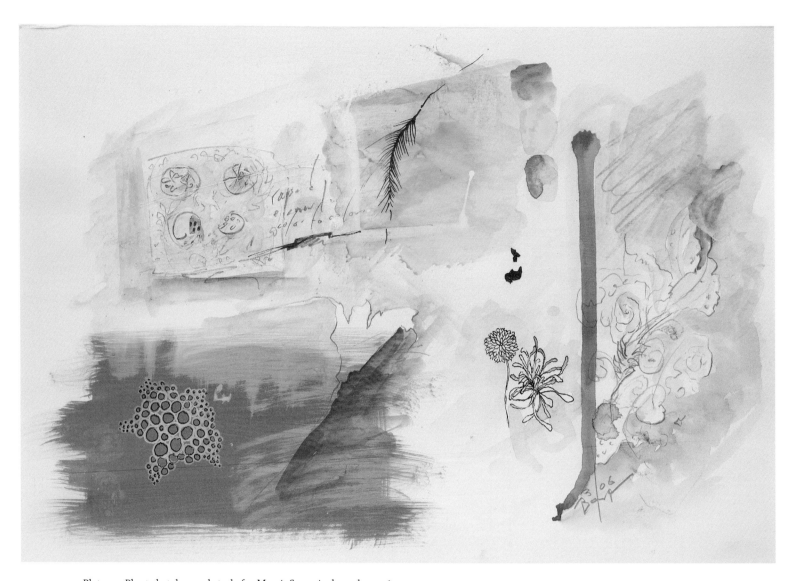

Plate 90 Plant sketches and study for *Mosaic Scenarios* brooch, 2006
Graphite, watercolor, gouache on wove paper
18 × 26 in.
Cat. No. 122

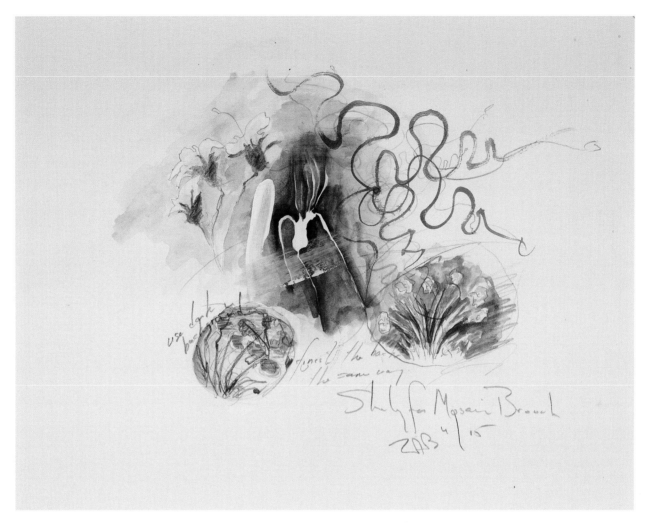

Plate 91 Study for *Mosaic Scenarios* brooch, 2005
Graphite, watercolor, gouache on wove paper
11 × 14⅛ in.
Cat. No. 123

Checklist of the Exhibition

All ornaments are brooches unless otherwise noted. Dimensions for the jewelry are given as height × width × depth (where known); dimensions for paintings and works on paper are given as height × width, unframed (unless otherwise noted).

Jewelry

1. *Silver Fleece*, 1976–1977 — Plate 1
Enamel, copper, silver
3 × 2⅝ in.
Collection of Arkansas Arts Center Foundation, Little Rock, Arkansas, Purchase Award: 11th Annual Prints, Drawings and Crafts Exhibition, 1978.009.00f

2. *Shirt Pattern 3, White* series (neckpiece), 1977 — Plate 2
Enamel, copper, silver
1⅝ × 1¹³⁄₁₆ in.; chain: 17½ in.
Collection of Joanne Markell

3. *Short Sleeve Pattern, White* series, 1978
Enamel, copper, silver
2 × 1¾ × 2¼ in.
Collection of Claire Sanford

4. *Raglan, White* series (pendant), 1979 — Plate 3
Enamel, copper, silver
2¼ × 2¼ in.
Los Angeles County Museum of Art, Los Angeles, California, Gift of June Schwarcz, M.2007.78

5. *Pattern, Black Fragment* series, 1978 — Plate 4
Enamel, copper, silver
1⅞ × 1¾ × ½ in.
Collection of Belle and Roger Kuhn

6. *Black Basilica 15, Black Fragment* series, 1979 — Plate 5
Enamel, copper, silver
1¼ × 3¼ in.
Collection of Victoria Z. Rivers

7. *Black Pivotal 6, Black Fragment* series, 1979 — Plate 6
Enamel, copper, silver
1½ × 3¼ in.
Collection of Martha Banyas

8. *Black Basilica 2*, 1979
Enamel, copper, silver
1⅛ × 2¼ × ⁵⁄₁₆ in.
Courtesy of Sienna Gallery, Lenox, Massachusetts

9. *Red Site 1*, 1980 — Plate 7
Enamel, copper, silver
1⅞ × 2¼ × ¼ in.
Courtesy of Jane Groover, Taboo Studio, San Diego, California

10. *Red Site 2*, 1980 — Plate 7
Enamel, copper, silver
1⅝ × 2½ × ¼ in.
Collection of Doug and Jackie Steakley

11. *Red Site 3*, 1980 — Plate 7
Enamel, copper, silver
1⅞ × 2¼ × ⁵⁄₁₆ in.
Collection of Victoria Z. Rivers

12. *Red Site 6*, 1982
Enamel, copper, silver
2 × 2³⁄₁₆ × ¼ in.
Samuel Dorsky Museum of Art, State University of New York, New Paltz, Gift of the artist, 2005.048

13. *Coral Tesserae* (neckpiece), 1984 — Plate 8
Enamel, copper, silver, black chrome
10⅛ × 6½ × ⅝ in.
Collection of Donna Schneier

14. *Delta, Tesserae* series (neckpiece), 1984 — Plate 9
Enamel, copper, silver, black chrome
Approx. 9¾ × 6 × ⅜ in.
Collection of Wita Gardiner

15. *Blue Spiral*, 1985 — Plate 10
Enamel, copper, silver
1¾ × 1¹³⁄₁₆ × ¼ in.
Collection of Martha Head

16. *Appalachian Spring, Tesserae* series, 1984 — Plate 11
Enamel, copper, silver
1⅜ × 1⅜ × ¼ in.
Collection of Barbara McFadyen

17. *November Fragment*, 1985 — Plate 12
Enamel, copper, silver
1½ × 4½ × ⅜ in.
Collection of Robert L. Pfannebecker

18. *Coloratura 3*, 1985 — Plate 13
Enamel, copper, silver, gold
4 × 1½ × ¼ in.
Collection of Eleanor T. Rosenfeld

19. *Coloratura 12*, 1985
Enamel, copper, silver
1¾ × 4½ × ⅜ in.
Collection of Wita Gardiner

20. *Totem, Coloratura* series, 1985 — Plate 14
Enamel, copper, silver
4⅜ × 1³⁄₁₆ × ¾ in.
Museum of Fine Arts, Houston, Texas, Helen Williams Drutt Collection, Gift of Helen Williams Drutt English, 2003.917

21. *Body, Bottle and Body* series, 1985 — Plate 15
Enamel, copper, silver
4¾ × ¹⁵⁄₁₆ × ⅛ in.
Collection of Sandy and Lou Grotta

22. *Trilogy, Bottle and Body* series, 1985
Enamel, copper, gold
Left: 4½ × ¾ × ⅜ in., center: 4⅛ × ⅞ × ⅜ in., right: 4⅛ × ⅞ × ⅜ in.
Collection of Anne and Ronald Abramson

23. *Deerrun 2*, c. 1985–1986 — Plate 16
Enamel, copper, silver
1¹¹⁄₁₆ × 4⁵⁄₁₆ × ¼ in.
Museum of Fine Arts, Boston, The Daphne Farago Collection, 2006.61.

24. *Deerrun 8*, c. 1985–1986
Enamel, copper, silver
4⅝ × 2¼ in.
Collection of Anne and Ronald Abramson

25. *Deerrun 10*, c. 1985–1986
Enamel, copper, silver
1¾ × 4⅝ × ⅜ in.
Collection of Anne and Ronald Abramson

26. *Deerrun 14*, c. 1985–1986 — Plate 17
Enamel, copper, silver, gold
1¼ × 4¼ × ¼ in.
Collection of Rachelle Thiewes

27. *Calypsos 1*, c. 1985–1986
Enamel, copper, silver
4½ × 2⅜ × ⅜ in.
Collection of Anne and Ronald Abramson

28. *Calypsos 2*, 1986 — Plate 18
Enamel, copper, silver, gold
4½ × 2½ × ½ in.
Collection of Daniel and Harriet Tolpin

29. *Calypsos 4*, 1986 — Plate 19
Enamel, copper, silver
4½ × 2⅜ × ⅜ in.
Collection of Kathy Sackheim

30. *Aioula 11*, 1988 — Plate 20
Enamel, copper, silver, gold
5 × 2½ × ½ in.
Estate of Edna Sloan Beron

31. *Aioula 16*, 1988 — Plate 21
Enamel, copper, silver, gold
3½ × 2 × ¼ in.
Private collection

Checklist of the Exhibition

32. *Aioula 19*, 1988 — Plate 22
Enamel, copper, silver, gold
4¾ × 2 × 1⅞ in.
Museum of Arts & Design, New York,
Gift of Romala and Dan Booton, 1993.69
*Fuller Craft Museum only

33. *Commemorative 1*, 1989
Enamel, copper
4 × ½ × ⅜ in.
Collection of Sarah Bodine

34. *Priori 3*, 1988 — Plate 23
Enamel, copper, gold
5½ × ¾ × ⅝ in.
Collection of Audrey S. Foster

35. *Priori 8*, 1989
Enamel, copper, gold
5½ × 1⅜ × ½ in.
Collection of Joanne Markell

36. *Priori 10*, 1988 — Plate 24
Enamel, copper, gold
5¼ × 2½ × ½ in.
Collection of Emily Gurtman

37. *Priori 16*, 1989 — Plate 24
Enamel, copper, gold
4¾ × 3¼ × ½ in.
Collection of Susan Grant Lewin

38. *Priori 17*, 1989 — Plate 25
Enamel, copper, gold
4¼ × 1½ × ⅜ in.
Collection of Jane Korman

39. *Priori 21*, 1987 — Plate 26
Enamel, copper, gold
5¾ × ⅜ × 1 in.
Collection of Vanessa S. Lynn

40. *Priori 25*, 1989
Enamel, copper, gold
5½ × 1½ × ⅜ in.
Collection of Cathy Shuman Trivers

41. *Uffilia 5* (neckpiece), 1991 — Plate 27
Enamel, copper, gold
11¼ × 6½ × ½ in.
Collection of Donna Schneier

42. *Black Bird 3*, 1990 — Plate 28
Enamel, copper
2⅝ × 4½ × ½ in.
Courtesy of Sienna Gallery, Lenox, Massachusetts

43. *Chroma 3*, 1991 — Plate 29
Enamel, copper
2¼ × 4½ × ½ in.
Collection of Sharon M. Campbell

44. *Rocaille 5*, 1991
Enamel, copper
5 × 1½ × ½ in.
Courtesy of Sienna Gallery, Lenox, Massachusetts

45. *Rocaille 6*, 1991 — Plate 30
Enamel, copper
5⅛ × 1½ × ¼ in.
Collection of Judith Downes and David Davis

46. *Rocaille 9*, 1991 — Plate 31
Enamel, copper
4½ × 1⅝ × ⅜ in.
Collection of Susan Ringer Koons

47. *Rocaille 12*, 1991 — Plate 32
Enamel, copper, gold
4¼ × 3½ × ⅝ in.
Museum of Fine Arts, Houston, Texas, Helen Williams Drutt
Collection, Gift of Helen Williams Drutt English, 2003.918

48. *Rocaille 14*, 1992 — Plate 33
Enamel, copper, gold
6 × 2¼ × ½ in.
Collection of Janet Kardon
*Fuller Craft Museum only

49. *Rocaille 19*, 1992 Plate 34
Enamel, copper
5 × 3½ × ½ in.
Collection of Fuller Craft Museum, Brockton,
Massachusetts, Gift of Julie M. Bernson in honor of
Jennifer L. Atkinson, 2004.3

50. *Blue Marker, Petrossa 4*, 1992
Enamel, copper, gold
5½ × ¾ × ¾ in.
Collection of Donna Schneier

51. *Jurjani 3*, 1997
Enamel, copper, gold
2⅞ × 1¼ × ½ in.
Collection of Hiko Mizuno College of Jewelry,
Tokyo, Japan

52. *Jurjani 4*, 1997 Plate 35
Enamel, copper, gold
2⅞ × 1⅞ × ⅜ in.
Museum of Fine Arts, Boston,
The Daphne Farago Collection, 2006.64

53. *Jurjani 6*, 1998 Plate 36
Enamel, copper, gold
2⅜ × 2½ × ⅜ in.
Collection of Sharon M. Campbell

54. *Jurjani 7* (neckpiece), c. 2000–2002 Plate 37
Enamel, copper, silver, gold
Length: 22¼ in.
Smithsonian American Art Museum, Washington, D.C.,
Gift of Ina and Jack Kay, 2003.46

55. *Jurjani 8*, 1998 Plate 38
Enamel, copper, gold, silver
2 × 3 in.
Mint Museum of Craft + Design, Charlotte, North Carolina,
Museum Purchase: Funds provided by Patricia Shaw, Joanne
Markell, and Donna Schneier, 1998.130

56. *Jurjani 9*, 1998
Enamel, copper, gold, silver
3 × 1⅝ × ⅜ in.
Collection of Barbara Waldman

57. *Composed Garden 1*, 1999 Plate 39
Enamel, copper, gold
2⅝ × 1 × ⅝ in.
Collection of Lola Brooks

58. *Composed Garden 2*, 1999
Enamel, copper, gold
3 × 3 × ½ in.
Collection of Anne and Ronald Abramson

59. *Composed Garden 3*, 1999 Plate 40
Enamel, copper, gold
2¼ × 2¼ × ½ in.
Collection of Diane and Marc Grainer

60. *Composed Garden 6*, 1999 Plate 41
Enamel, copper, gold
3 × 3 × ⅜ in.
Collection of Lisa Shaffer Anderson

61. *Composed Garden 12*, 1999 Plate 42
Enamel, copper, gold
1½ × 2 × ⅜ in.
Collection of Sharon M. Campbell

62. *Melancholia*, 1999 Plate 43
Enamel, copper, gold, silver
1¾ × 1⁹⁄₁₆ × ½ in.
Collection of Barbara McFadyen

63. *Star-Eyed Brooch*, 1999 Plate 44
Enamel, copper, gold
3 × 1⅞ × ½ in.
Collection of Susan C. Beech

64. *Chadour* (neckpiece), 2000 Plate 45
Enamel, copper, gold
7⅜ × 5⅜ × ½ in.
Private collection
*Fuller Craft Museum only

65. *Chadour 6*, 2000 Plate 46
Enamel, copper, gold
2¼ × 1 × ½ in.
Collection of Kathy Sackheim

Checklist of the Exhibition

66. *Chadour 9*, 2000 — Plate 47
Enamel, copper, gold
2⅝ × 1 × ⅝ in.
Collection of Barbara Waldman

67. *Chadour 17*, 2001 — Plate 48
Enamel, copper, gold
⅜ × 1 × 1 in.
Courtesy of Sienna Gallery, Lenox, Massachusetts

68. *Lumen 1*, 2000 — Plate 49
Enamel, copper, gold
Height: ⅝ in., diameter: 2½ in.
Collection of Hiko Mizuno College of Jewelry, Tokyo, Japan

69. *Lumen 4*, 2000 — Plate 50
Enamel, copper, gold
Height: ⅝ in., diameter: 2⅛ in.
Collection of Hiko Mizuno College of Jewelry, Tokyo, Japan

70. *Lumen 8*, 2000
Enamel, copper, gold
Height: ⅝ in., diameter: 2⅛ in.
Courtesy of Sienna Gallery, Lenox, Massachusetts

71. *Safavid 2*, 2002 — Plate 51
Enamel, copper, gold
2 × ⅞ × ⅜ in.
Private collection

72. *Circadian 1* (neckpiece), c. 2000–2003
Enamel, copper, silver, gold
Length: 34½ in.
Collection of Susan C. Beech

73. *Florilegium* (neckpiece), 2002 — Plate 52
Enamel, copper, gold
Length: 42 in.
Collection of Marion Fulk

74. *Florilegium 1*, 2002 — Plate 53
Enamel, copper, gold
Height: ½ in., diameter: 2¼ in.
Collection of Anne and Ronald Abramson

75. *Florilegium 2*, 2002–2003 — Plate 54
Enamel, copper, gold
4 × 3 × ½ in.
Collection of Anne and Ronald Abramson

76. *Florilegium 3*, 2003 — Plate 55
Enamel, copper, gold
5 × 2 × ½ in.
Collection of Susan C. Beech

77. *Mosaic Scenarios 1*, 2005 — Plate 56
Enamel, copper, gold
2⅜ × 2⅛ × 3/16 in.
Courtesy of Sienna Gallery, Lenox, Massachusetts

78. *Mosaic Scenarios 4*, 2005 — Plate 57
Enamel, copper, gold
2⅜ × 2⅛ × ⅛ in.
Private collection

79. *Mosaic Scenarios 5*, 2005 — Plate 58
Enamel, copper, gold
Height: 3/16 in., diameter: 2 in.
Private collection

80. *Mosaic Scenarios 7*, 2005
Enamel, copper, gold
2¼ × 2¼ × ½ in.
Collection of Sienna Patti

81. *Blue Mosaic 9* (neckpiece), 2005 — Plate 59
Enamel, copper, gold
Length: 26 in.
Collection of Allen and Irene Natow

82. *Mosaic Scenarios 9*, 2005
Enamel, copper, gold
1⅞ × 1⅞ × 3/16 in.
Courtesy of Sienna Gallery, Lenox, Massachusetts

83. *Mosaic Scenarios 10*, 2005 — Plate 60
Enamel, copper, gold
1⅞ × 1⅞ × 3/16 in.
Courtesy of Sienna Gallery, Lenox, Massachusetts

84. *Polonaise 1*, 2004 Plate 61
Enamel, copper, gold
2⅛ × 2¼ × ⅜ in.
Collection of Lisa Shaffer Anderson

85. *Polonaise 2*, 2005
Enamel, copper, gold
2¼ × 2¼ × ½ in.
Courtesy of Sienna Gallery, Lenox, Massachusetts

86. *Urban Traces 1* (neckpiece), 2005 Plate 62
Enamel, copper, gold
Length: 28½ in.
Collection of Allen and Irene Natow

87. *Urban Traces 1*, 2006 Plate 63
Enamel, copper, gold
1½ × 1¾ × ⅛ in.
Courtesy of Sienna Gallery, Lenox, Massachusetts

88. *Urban Traces 2*, 2006 Plate 64
Enamel, copper, gold
1¾ × 2⅜ × 3/16 in.
Courtesy of Sienna Gallery, Lenox, Massachusetts

89. *Urban Traces 4* (neckpiece), 2006 Plate 65
Enamel, copper, gold
Length: 36 in.
Courtesy of Sienna Gallery, Lenox, Massachusetts

90. *Urban Traces 7*, 2006 Plate 66
Enamel, copper, gold
2 × 2¼ × 3/16 in.
Courtesy of Sienna Gallery, Lenox, Massachusetts

Wall Reliefs

91. *Pattern* triptych, *White* series, 1979 Plate 67
Enamel, copper
Overall: 10⅛ × 12 × 1½ in.
Courtesy of Sienna Gallery, Lenox, Massachusetts

92. *Pattern Fragment*, *Black Fragment* series, 1980 Plate 68
Enamel, copper, silver
Overall: 5 × 5 in.
Collection of Robert L. Pfannebecker

93. *Spiral Tesserae*, 1983 Plate 69
Enamel, copper, paint, wood
7 × 14 × 2 in. (framed)
Racine Art Museum, Racine, Wisconsin, Gift of Robert W. Ebendorf and Aleta Braun,

94. *Figure and Fragment 282*, 1982
Enamel, copper, maple
9⅜ × 15⅜ × 1 in.
Smithsonian American Art Museum, Gift of National Enamelist Guild, Anne and Ronald Abramson, Dalene Barry and Joseph Dean, and Belle and Roger Kuhn, 1983.61

95. *Joseph & Josephine*, 1985
Enamel, copper, wood, paint
18 × 12 × 4 in.
Fuller Craft Museum, Brockton, Massachusetts, Commissioned with a New Works Grant from the Massachusetts Council on the Arts and Humanities, 1985.8.3

96. *End of the Table*, 1991 Plate 70
Oil and polymer on panel, forged bronze
18 × 30 × 5 in.
Estate of Edna Sloan Beron

97. *Bottle with Two References 10*, 1991 Plate 71
Mixed media
24 × 17 in. overall
Samuel Dorsky Museum of Art, State University of New York, New Paltz, Gift of the artist, 1995.023.003a-c

98. *Red Steps*, 1998 Plate 72
Polymer, oil, encaustic, wood, enamel, copper
18 × 12½ × 4½ in.
Collection of Judith Downes and David Davis

99. *Making Hybrids 1*, 1999 Plate 73
Polymer, encaustic, oil, wood, enamel, copper
30½ × 6½ × 5½ in.
Courtesy of Fidelity Investments Corporate Art Collection, Boston

100. *Making Hybrids, 2*, 1999 Plate 73
Polymer, encaustic, oil, wood, enamel,
copper, embroidered textile
30½ × 6½ × 5½ in.
Courtesy of Fidelity Investments Corporate Art Collection,
Boston

101. *Coup de fleur*, 2000 Plate 74
Enamel, copper, wood
10 × 8½ in.
Collection of Kathy and Gordon Weil

102. *Blue Pleasures*, 2001
Watercolor, gouache, graphite on paper, enamel, copper,
gold, wood
22½ × 11¾ × 4½ in.
Collection of Eileen Marcuvitz

103. *Woodland Spectacle*, 2006 Plate 75
Enamel, copper, wood, looking glass
10⅞ × 11⅞ × 2⅛ in.
Collection of Judith Downes and David Davis

Paintings & Drawings

104. *Three Ravens and Red Barn*, 1994 Plate 76
Oil, polymer, and encaustic on paper
42 × 30 in.
Collection of Kiwon Wang

105. *Gautama and Rose*, 1997 Plate 77
Oil and polymer on paper
50 × 41 in.
Collection of Bernadine and J. Dale Bennett

106. *Planning Gestures*, 1998
Oil and polymer on paper
20 × 24 in.
Collection of Diane and Mark Grainer

107. *Mediating Use*, 1998 Plate 78
Oil and polymer on paper
20 × 24 in.
Private collection

108. *Domestic Rescue*, 1998 Plate 79
Oil and polymer on paper
72 × 9 in.
Private collection

109. *Sentimental Signals*, 1998 Plate 80
Oil and polymer on paper
72 × 9 in.
Collection of Robert and Elizabeth Weiler

110. *Daily Quote*, 1998
Polymer and oil on paper
72 × 9 in.
Courtesy of Fidelity Investments Corporate Art Collection,
Boston

111. *Hiroshige, Vincent, and Chrysanthemum*, 2004 Plate 81
Oil, encaustic, and polymer on paper
25 × 30 in.
Collection of Haluk and Elisa Soykan
*Fuller Craft Museum only

112. *Yellow Dots and Labyrinth*, 2004
Oil and polymer on paper
19 × 25½ in.
Courtesy of Clark Gallery, Lincoln, Massachusetts

113. *Vista with Blue Spruce*, 2004
Oil, polymer, and encaustic on paper
25 × 29½ in.
Courtesy of Clark Gallery, Lincoln, Massachusetts

114. *Candidium Blue*, 2003 Plate 82
Oil and polymer on paper
30⅞ × 45⅜ in.
Courtesy of Fidelity Investments Corporate Art Collection,
Boston

115. *Le Soir Frieze*, 2004 Plate 83
Oil and polymer on paper
25½ × 40 in.
Courtesy of Clark Gallery, Lincoln, Massachusetts

116. Studies for *Appalachian Spring*, 1984 Plate 84
Graphite and watercolor on paper
16¼ × 17½ × ¾ in. framed
Collection of Barbara McFadyen

117. Studies for *Bottle and Body* series (sketchbook), 1985
Graphite and watercolor on wove paper
7⅜ × 11¾ in.
Collection of the artist

Plate 85

118. Study for *Rocaille* (sketchbook), c. 1991–1992
Watercolor and gouache on wove paper
7⅜ × 5⅝ in.
Collection of the artist

Plate 86

119. Landscape study (sketchbook), 2004
Graphite, watercolor, gouache on wove paper
10⅜ × 8¼ in.
Collection of the artist

Plate 87

120. Study for *Star-Eyed Brooch*
Graphite and watercolor on wove paper
5 × 6½ in.
Collection of the artist

Plate 88

121. Study for flowered wall decoration, c. 2000
Graphite, colored pencil, watercolor, and gouache on wove paper
9 × 12⅛ in.
Collection of the artist

Plate 89

122. Plant sketches and study for *Mosaic Scenarios* brooch, 2006
Graphite, watercolor, gouache on wove paper
18 × 26 in.
Collection of the artist

Plate 90

123. Study for *Mosaic Scenarios* brooch, 2005
Graphite, watercolor, gouache on wove paper
11 × 14⅛ in.
Collection of the artist

Plate 91

Jamie Bennett, ca. 1985. Collection of the artist.

Appointments, Fellowships, Artist Residencies, Selected Lectures

Appointments

1985–present	Professor, State University of New York, New Paltz
2002–2004	Chair, Art Department, State University of New York, New Paltz
1999–2005	Graduate Coordinator, State University of New York, New Paltz
1980–1985	Professor, Boston University, Program in Artisanry, Boston, Massachusetts
1976–1978, 1980	Professor, Memphis Art Academy, Memphis, Tennessee
1974–1976	Professor, Bradley University, Peoria, Illinois

Fellowships, Artist Residencies

2004	Corcoran School of Art, Washington, D.C.
2001	Kunsthal, School of Art and Design, *Blue Jewelry*, Gothenburg, Sweden
2000	Hiko Mizuno College of Jewelry, *The Culture of Jewelry*, Tokyo, Japan
1999	Myers School of Art, Akron University, Ohio
1999	Munich Academy of Art, Jewelry Department, Munich, Germany
1999	Fellowship, New York Foundation for the Arts
1990	Fellowship, New York Foundation for the Arts
1988	Individual Fellowship, National Endowment for the Arts
1985	Istanbul Technical University, Department of Architecture and Design, Istanbul, Turkey
1984	Massachusetts Artist Fellowship, Massachusetts Council for the Arts
1979	Individual Fellowship, National Endowment for the Arts
1973	Individual Fellowship, National Endowment for the Arts

Selected Lectures

"Ornamental Habits," University of Wisconsin, Milwaukee, Wisconsin, 2004

"Historicizing in American Metal," Massachusetts College of Art, Boston, 2004

"The Evocative Object," Rhode Island College, North Providence, Rhode Island, 2003

"Sins of the Sublime," Towson University, Towson, Maryland, 2003

"Developments in Contemporary Enamel," National Ornamental Metal Museum, Memphis, Tennessee, 2002

"Contemporary Silver: Irony and Empathy," *Sterling Modernities: International and American Silver from the Arts and Crafts Movement to the Present* (symposium), New York University School of Continuing and Professional Studies, 2002

"Jewelry and Ornamental Impulses," Annual conference, Society of North American Goldsmiths, Richmond, Virginia, 2001

"Jamie Bennett: Recent Works," Rohss Museum of Art, Gothenburg, Sweden, 2001

"The Future of Crafts Education and the Crafts," Cleveland Institute of Art, Cleveland, Ohio, 1999

"Ornamentation: It's Not a Sin," Cleveland Institute of Art, Cleveland, Ohio, 1999

"Traditions and Transformations: Working Locally," International Enameling Conference, Arrowmont Center for the Arts, Gatlinburg, Tennessee, 1998

Selected Exhibitions

Solo Exhibitions

Jamie Bennett: Abstracting Eden, Sienna Gallery, Lenox, Massachusetts, 2005
Jamie Bennett: Landscape Vignettes, Clark Gallery, Lincoln, Massachusetts, 2004
Jamie Bennett: Smyckekonstnar fran USA, Gallieri Hnoss, Gothenburg, Sweden, 2001
Jamie Bennett: Blue Pleasures, Susan Cummins Gallery, Mill Valley, California, 2001
Twenty Pendants: Jamie Bennett, Sienna Gallery, Lenox, Massachusetts, 2001
Jamie Bennett: New Work, Gallery YU, Hiko Mizuno College of Jewelry, Tokyo, 2000
Jamie Bennett: Schmuckobjekte, Tiller and Ernst Gallery, Vienna, 2000
Jamie Bennett: New Work, Mobilia Gallery, Boston, Massachusetts, 2000
Jamie Bennett: Gardening, Susan Cummins Gallery, Mill Valley, California, 1999
Jamie Bennett: Jurjani Series, Susan Cummins Gallery, Mill Valley, California, 1996
James Bennett: Jewelry, Barbara Okun Gallery, Tesuque, New Mexico, 1996
Jamie Bennett: Time and Meaning, Clark Gallery, Lincoln, Massachusetts, 1995
Jamie Bennett: Ambage, Helen Drutt Gallery, Philadelphia, 1994
Jamie Bennett: The Domestic Distance, Clark Gallery, Lincoln, Massachusetts, 1993
James Bennett: Seize anneés de creation, 1976–1992, Galerie Jocelyne Gobeil, Montreal, 1992
James Bennett: Encaustic Paintings, Clark Gallery, Lincoln, Massachusetts, 1991
Bennett: Recent Jewelry, Schneider Gallery, Chicago, 1990
Bennett: Small Drawings, J. Cotter Gallery, Vail, Colorado, 1990
Jamie Bennett, CDK Gallery, New York City, 1989
Jamie Bennett: Paintings, Clark Gallery, Lincoln, Massachusetts, 1989
Jamie Bennett: Recent Works, Fergus-Jean Gallery, Cleveland, Ohio 1988
Jamie Bennett: Drawings and Boxes, Clark Gallery, Lincoln, Massachusetts, 1987
Jamie Bennett/USA, Galerie Phillipe Debray, Riihimaki, Finland 1987
Jamie Bennett: Recent Works, Esther Saks Gallery, Chicago, 1986
Jamie Bennett Selects, Plum Gallery, Washington, D.C., 1985
Jamie Bennett—Drawings and Wall Reliefs, Fergus-Jean Gallery, Harbor Springs, Michigan, 1985
Jamie Bennett, Plum Gallery, Washington, D.C., 1983
Jamie Bennett, Helen Drutt Gallery, Philadelphia, 1985
Jamie Bennett: Metalwork and Drawings, Eastern Kentucky University, Richmond, Kentucky, 1980
New Constructions: Enamel Reliefs by J. Bennett, Art Gallery, University of Texas, Arlington, Texas, 1982
Jamie Bennett: New Works, The Works Gallery, Southampton, New York, 1978

Group Exhibitions

Jewelry by Artists: The Daphne Farago Exhibition, Museum of Fine Arts, Boston, 2007–2008
Schmuck 2006, Handwerkskammer für München, Munich, Germany, and Museum of Arts & Design, New York City, 2006
Metalisms, Center for Visual Arts, Denver, Colorado, 2005
100 Brooches, Sharon Campbell, Spiral Gallery, Seattle, Washington, 2005
Juxtapositions, Samuel Dorsky Museum of Art, State University of New York, New Paltz, New York, 2005
June Show, Pacini Lubel Gallery, Seattle, Washington, 2005
The Art of Enameling, Lowe Gallery, Cleveland, Ohio, 2005
Enameling 2005, Taboo Gallery, San Diego, California, 2005
The Perfect Collection, Fuller Craft Museum of Art, Brockton, Massachusetts, 2004
The Nature of Craft and the Penland Experience, Mint Museum of Craft & Design, Charlotte, North Carolina, 2004
Treasures from the Vault, Museum of Arts & Design, New York City, 2004
Gold, Sienna Gallery, Lenox, Massachusetts, 2004
Ornament as Content, Hay Gallery, Portland, Maine, 2003
Craft Transformed: Program in Artisanry, Boston University, 1975–1985, Fuller Museum of Art, Brockton, Massachusetts, 2003
Micromegas, Powerhouse Museum, Sydney, Australia, 2003
Micromegas, Curtin Gallery, Curtin University, Perth, Australia, 2003

ICE, Heller Gallery, New York City, 2003
Jewels and Gems, Renwick Gallery, Smithsonian American Art Museum, Washington, D.C., 2003
2002, Spectrum Gallery, Munich, Germany, 2002
Metal Under Glass: A Collection of Contemporary Metal and Enamel Work, Southwest Missouri State University, Springfield, Missouri, 2002
Markers in Contemporary Metal, Samuel Dorsky Museum of Art, State University of New York, New Paltz, 2002
Generating Connections: Emerging Artists & Mentors, Society of Arts and Crafts, Boston, 2002
Expressions: Clay, Fiber, Metal, Schick Art Gallery, Skidmore College, Saratoga Springs, New York, 2002
Color + Reflection, Arrowmont School of Arts and Crafts, Gatlinburg, Tennessee, 2001
Jewelry as an Object of Installation, Susan Cummins Gallery, Mill Valley, California, 2001
Enamel Jewelry, Sybaris Gallery, Royal Oak, Michigan, 2001
Precious, Sienna Gallery, Lenox, Massachusetts, 2000
Five From New Paltz, New York Foundation for the Arts Recipients, Woodstock Art Guild, Woodstock, New York, 2000
Beyond the Obvious: Rethinking Jewelry, San Francisco Craft and Folk Art Museum, San Francisco, California, 1999
Masterworks, Harbinger Gallery, Waterloo, Ontario, Canada, 1999
1950–2000: Fifty Years of Studio Jewelry, Mobilia Gallery, Cambridge, Massachusetts, 1999
Jewellery Moves: Ornament for the 21st Century, National Museum of Scotland, Edinburgh, Scotland, 1999
Email, Atelier für Schmuck, Stuttgart, Germany, 1999
Celebrating American Craft: American Craft, 1975–1995, Danish Museum of Decorative Art, Copenhagen, Denmark, 1997
Three Generations, Mobilia Gallery, Cambridge, Massachusetts, 1997
Jewellery in Europe and America: New Times, New Thinking, Crafts Council of Great Britain, London, 1996
Subjects 96: International Jewelry Art Exhibition, Retretti Art Centre, Punkaharju, Finland, 1996
In Touch: Nytt Kunsthandverk, Olympic Village Hall Lillehammer, Norway, 1994
Internationale Craft Triennale, Gallery of Western Australia, Perth, Australia, 1992
Five Enamelists, Hipotessi Gallery, Barcelona, Spain, 1990
Crafts Today USA, American Craft Council, New York, 1989
Ornamenta 1: Internationale Austellung zeitgenössischer Schmuckkunst [International Exhibition of Contemporary Jewelry] Reuchlinhaus, Pforzheim, Germany, 1989
Poetry of the Physical, American Craft Museum, New York City, 1986
Masterworks of Contemporary American Jewelry: Sources and Concepts, Victoria and Albert Museum, London, 1985
American Jewelry Now, American Craft Museum and the Society of North American Goldsmiths, New York City, 1985
Jewelry U.S.A., Society of North American Goldsmiths and American Craft Museum, New York City, 1984
Bennett / Coles / Keens / Lloyd, Galveston Art Center, Galveston, Texas, 1983
Jamie Bennett / David Keens—New Constructions, Fine Arts Gallery, Cabrillo College, Aptos, California, 1982
'81 International Exhibition of Enameling Art, Tokyo Central Museum, Tokyo, Japan, 1981
Good as Gold: Alternative Materials in American Jewelry, Renwick Gallery, Smithsonian Institution, Washington, D.C., 1981
Metalsmith '81, Society of North American Goldsmiths, Visual Arts Gallery, Lawrence, Kansas, 1981
Enamels Today, Worshipful Company of Goldsmiths, London, 1981
Schmuck International, 1900–1980, Künstlerhaus, Vienna, Austria, 1980
13th Biennial Prints, Drawings Exhibition, Arkansas Arts Center, Little Rock, Arkansas, 1978
Modern American Jewelry Exhibition, Mikimoto Galleries, Tokyo, Japan, 1978
American Goldsmith, Society of North American Goldsmiths, 1978–1981
Schmuck-Tendenzen '77, Pforzheim Schmuckmuseum, Pforzheim, Germany, 1977
Artwear, Artwear Gallery, New York City, 1977
L'art de l'email, 3e biennale internationale, Chapelle de Lycée Gay-Lussac, Limoges, France, 1975
Baroque '74, Museum of Contemporary Crafts, New York City, 1974
The Goldsmith: An Exhibition of Work by Contemporary Artists-craftsmen of North America, Minnesota Museum of Art, St. Paul, Minnesota, 1974
Sterling Silver Design Competition, Lever House, New York City, 1973
The Art of Enamels, State University of New York, New Paltz, 1973
Objects for Preparing Food, Museum of Contemporary Crafts, New York City, 1972

Public and Corporate Collections

Akron University, Akron, Ohio
Arkansas Decorative Arts Museum, Little Rock, Arkansas
Arrowmont Center for Crafts, Gatlinburg, Tennessee
Fidelity Investments Corporate Art Collection, Boston, Massachusetts
Fuller Craft Museum, Brockton, Massachusetts
Hiko Mizuno Collection of International Jewelry, Hiko Mizuno College of Jewelry, Tokyo
Kunstsmuseum, Oslo, Norway
Kunstsmuseum, Trondheim, Norway
Los Angeles County Museum of Art, Los Angeles, California
Mint Museum of Art, Charlotte, North Carolina
Musée des arts décoratifs, Paris
Museum of Arts & Design, New York City
Museum of Fine Arts, Boston, Massachusetts
Museum of Fine Arts, Houston, Texas
Museum of Western Australia, Perth, Australia
Philadelphia Museum of Art, Philadelphia
Racine Museum of Art, Racine, Wisconsin
Renwick Gallery, Smithsonian American Art Museum, Washington, D.C.
Rohss Museum of Applied Art and Design, Gothenburg, Sweden
Royal College of Art, London
Samuel Dorsky Museum of Art, State University of New York, New Paltz
University Museum, University of Georgia, Athens, Georgia
Victoria and Albert Museum, London

Awards

2003 Chancellor's Award for Excellence in Scholarship
and Creative Activity, State University of New York, New Paltz

Born 1948, Philadelphia

B.B.A. University of Georgia, 1970
M.F.A. State University of New York, New Paltz, 1974

Selected Bibliography

Archive

International Contemporary Vitreous Enamel Archive (ICVEA). Bristol School of Art, Media, and Design, University of the West of England, Bristol.

Books, Catalogues, and Periodicals

Adelman, Ann, and Arlene Fisch. *American Jewelry Now*. Exh. cat. New York: American Craft Museum and the Society of North American Goldsmiths, 1985.

American Craft Museum. *Crafts Today USA*. Exh. cat. New York: American Craft Council, 1989.

———. *Jewelry USA*. Exh. cat. New York: American Craft Museum, 1984.

Arkansas Art Center, Decorative Arts Museum. *Objects & Drawings II*. Exh. cat. Little Rock, Ark.: Arkansas Arts Center, 1994.

Barahal, Susan. "Jamie Bennett: The Domestic Distance." Review of exhibition at Clark Gallery, Lincoln, Massachusetts. *Metalsmith* 13, no. 4 (Fall 1993): 42.

Bennett, James. "Looking to Learn, Learning to Make." In *Color + Reflection*. Exh. cat. Newport, Ky.: Enamelist Society, 2001.

———. "Recent Sightings." *Metalsmith* 18, no. 5 (Fall 1998): 10–13.

———. "Jewelry Mediating Jewelry." *Metalsmith* 18, no. 1 (Winter 1998): 24–33.

———. "Enameling in Retrospect—Survey of Enameling Techniques." In *The Art of Enamels*, 61–70. Exh. cat. New Paltz, N.Y.: College Art Gallery, State University College, 1973.

Brown, Glen R. "Jamie Bennett: In Deference to the Decorative." *Metalsmith* 26, no. 1 (Spring 2006): 18–25.

———. "Metal Under Glass." Review of *Metal Under Glass* (exhibition) at Southwest Missouri State University Art and Design Gallery, Springfield. *Metalsmith* 22, no. 5 (Fall 2002): 49.

Browne, Kathleen. "Stigma of Beauty." In *Metal Under Glass: A Collection of Contemporary Metal and Enamel Work*, 12–14. Exh. cat. Springfield, Mo.: Art and Design Gallery, Southwest Missouri State University, 2002.

Carlock, Marty. "21st Century Metalsmiths: Individual and Collaborative Works." Review of exhibition at New Art Center, Newton, Mass. *Sculpture Magazine* 21, no. 1 (January 2002): 63–64.

Clark Gallery. *Jamie Bennett: Ordinary Sites*. Exh. cat. Lincoln, Mass.: Clark Gallery, 1999.

Cummins, Susan. *Beyond the Obvious: Rethinking Jewelry*. Exh. cat. San Francisco: San Francisco Craft and Folk Art Museum, 1999.

Danish Museum of Decorative Art. *Celebrating American Craft: American Craft, 1975–1995*. Exh. cat. Copenhagen: Danish Museum of Decorative Art, 1997.

Darty, Linda. *The Art of Enameling: Techniques, Projects, Inspiration*. New York: Lark Books, 2004.

Dormer, Peter, and Ralph Turner. *The New Jewelry: Trends + Traditions*. London: Thames and Hudson, 1985.

Dormer, Peter, et al. *In Touch: Nytt Kuknsthandverk*. Exh. cat. Lillehammer: Maihaugen, De Sandvigske Samlinger, 1994.

Dubois, Alan. Review of *Metal Under Glass* (exhibition) at Southwest Missouri State University, Springfield, Mo. *American Craft* 62, no. 4 (August–September 2002): 53–55.

Enamelist Society, *Color + Reflection*. Exh. cat. Newport, Ky.: Enamelist Society, 2001.

English, Helen W. Drutt, and Peter Dormer. *Jewelry of Our Time: Art, Ornament and Obsession*. New York: Rizzoli, 1995.

Fuller Museum of Art. *Craft Transformed: Program in Artisanry, Boston University, 1975–1985*. Exh. cat. Brockton, Mass.: Fuller Museum of Art, 2003.

Game, Amanda, and Elizabeth Goring. *Jewellery Moves: Ornament for the 21st Century*. Exh. cat. Edinburgh: National Museums of Scotland and NMS Pub., 1998.

Goss, Gretchen, and Maria Phillips. "Enamel, A Current Perspective." *Metalsmith*. 23, no. 4 (Fall 2003): 8.

Greenbaum, Toni. s.v. "Jamie Bennett." In *Dictionnaire international du bijou*, ed. Marguerite de Cerval. Paris: Editions du Regard, 1998.

Gregg, Gail. "What They're Teaching Art Students These Days." *Art News*. 102, no. 4 (April 2003): 106–109.

Herman, Lloyd E. *Color and Image: Recent American Enamels*. Exh. cat. Hamilton, N.Y.: Gallery Association of New York State, 1988.

———, and Betty Teller. *Good as Gold: Alternative Materials in American Jewelry*, Exh. cat. Washington, D.C.: Smithsonian Institution Traveling Exhibition Service, 1981.

Hynes, Bill, et al. *Crafts Symposium & Robert L. Pfannebecker Contemporary American Crafts Exhibit*. Exh. cat. Shippensburg, Pa: Shippensburg University Press, 1989.

"Jamie Bennett." *American Craft* 48, no. 6 (December 1988–January 1989): 31.

Komrad, Audrey. "Tradition & Transformation: The Sixth Biennial Conference of the Enamelist Society." *Glass on Metal* (U.S.A.). 16, no. 4 (December 1997): 84.

L'art de l'émail: 3e biennale internationale Exh. cat. Limoges, France: Chapelle de Lyceé Gay-Lussac, 1975.

Le Van, Marthe. 500 *Brooches: Inspiring Adornments for the Body.* New York: Lark Books, 2005.

Lewin, Susan Grant. *One of a Kind: American Art Jewelry Today.* New York: Harry N. Abrams, 1994.

Licka, C. E. "Contrapuntal Sensibilities." In *Jamie Bennett / David Keens: New Constructions*. Exh. cat. Arlington, Tex.: University of Texas at Arlington, n.p.

Lynn, Vanessa. "Robert Ebendorf and Jamie Bennett: Masters of Matters that Matter." *Art Today* 5, no. 4 (1991): 28–33.

———. "Jamie Bennett: In the Beginning (Again)." *Metalsmith* 10, no. 2 (Spring 1990): 20–23.

Matthews, Glenice L. *Enamels, Enameling, Enamelists.* Rander, Penn.: Chilton Book Co., 1984.

McLaughlin, Jean W. *The Nature of Craft and the Penland Experience.* Exh. cat. New York: Lark Books in association with the Mint Museum of Craft + Design and Penland School of Crafts, 2004.

Metcalf, Bruce. "Recent Sightings." *Metalsmith* 18, no. 2 (Spring 1998): 8.

Mizuno, Takahiko. *Contemporary Jewelry: Eight International Jewelers.* Tokyo: Bijutsu Shuppan-sha, Ltd., 2007.

Modena, Charlene. "Jamie Bennett: Blue Pleasures." Review of exhibition at Susan Cummins Gallery, Mill Valley, California. *Metalsmith* 22, no. 1 (Winter 2002): 52.

Neuman, Ursula. "Der Schmuck entdeckt Amerika." *Kunsthandwerk & Design*, no. 2 (March–April 2006): 4–11.

Penn, Beverly. "From the Fire." Review of exhibition at Adair Margo Gallery, El Paso, Texas, 1993. *Metalsmith* 14, no. 1 (Winter 1994): 46–47.

Peter, Ruudt. *Schmuck 2006.* Exh. cat. Munich: GHM-Gesellschaft für Handwerksmessen mbH and Danner-Stiftung, 2006.

Phillips, Clare. *Jewels and Jewelry from the Collection of the Victoria and Albert Museum.* London: Victoria and Albert Publishing, 2000.

Porges, Maria. "Jewelry and Installation." Review of exhibition, *Jewelry as an Object of Installation*, Susan Cummins Gallery, Mill Valley, California, 2001. *American Craft* 62, no. 1 (February–March 2002): 74–79.

Pratt, Rosalind. *Virtual Gallery of Contemporary Jewellery.* CD-ROM. Birmingham: University of Central England, 2000.

"Quo Vadis." *Metalsmith* 25, no. 5 (Fall 2005): 22–23.

Rosolowski, Tracey A. "Markers in Contemporary Metal." Review of exhibition at Samuel Dorsky Museum of Art, State University of New York, New Paltz, 2002. *Metalsmith* 22, no. 5 (Fall 2002): 51.

Simon, Marjorie. "Jamie Bennett." Review of exhibition held at Helen Drutt Gallery, Philadelphia. *Metalsmith* 16, no. 5 (Fall 1996): 46.

Simon-Rössler, Angelika, and Bruno-Wilhelm Thiele. *Farbe aus dem Feuer: Faszination Email.* Exh. cat. Stuttgart, Germany: Rühle-Diebener-Verlag, 2000.

Skubic, Peter, *Schmuck International, 1900–1980.* Exh. cat. Vienna: Künstlerhaus, 1980.

Smith, Paul, and Edward Lucie-Smith. *Craft Today: Poetry of the Physical.* New York: American Craft Museum and Weidenfeld & Nicolson, 1986.

Southwest Missouri State University. *Metal Under Glass: A Collection of Contemporary Metal and Enamel Work.* Exh. cat. Springfield, Mo.: Art and Design Gallery, Southwest Missouri State University, 2002.

State University of New York. *The Art of Enamels.* Exh. cat. New Paltz, N.Y.: College Art Gallery, State University College, 1973.

Turner, Ralph. *Jewelry in Europe and America: New Times, New Thinking.* Exh. cat. London: Craft Council of Great Britain with Thames and Hudson, 1996.

Trapp, Kenneth R., et al. *Crossing Boundaries: Enamels 1999.* Exh. cat. Newport: Ky.: Enamelist Society, 1999.

Victoria and Albert Museum. *Masterworks of Contemporary American Jewelry: Sources and Concepts.* Exh. cat. London: Victoria and Albert Museum, 1985.

Watkins, David. *The Best in Contemporary Jewellery.* Mies, Switzerland: Rotovision, 1993.

Index

Page numbers in *italics* refer to illustrations.

abstraction, 19, 26, 31, 38
Aioula 11, 60
Aioula 16, 61
Aioula 19, 62
al-Jurjani, Abd al-Qahir, 21, 33
American Craft Council, 14
Appalachian Spring, Tesserae series, 19, 53
architecture, 29, 32, 34

Banyas, Martha, 15
baroque style, 32
Bates, Kenneth, 15
beauty, 28, 32–33
Bennett, Jamie, *12*, *14*, *134*
 appointments, fellowships, artist residencies, and selected lectures, 135
 apprenticeship and practice, 11–17
 collections, 138
 exhibition history, 136–37
 practice and style, 17–22
Black Basilica 15, Black Fragment series, 17, *48*
Black Bird 3, 67
Black Fragment series, 17, *48–49*, *103*
Blackman, Karen, 15
Black Pivotal 6, Black Fragment series, 17, *49*
Blue Marker, Petrossa 4, *72*
Blue Mosaic 9 (neckpiece), *93*
Blue Spiral, 53
Body, Bottle and Body series, 19, *56*
Body series, 19
Boston, 15–16
Boston University, Program in Artisanry (PIA), 15–16
botanical subjects, 16, 21, 22, 32
Bottle with Two References 10, *106*
Bradley University, Peoria, Illinois, 14
brooches, 17, 19, 20, 21, 29, 30–31, 32, 33, 34, 38, 40
Bury, Claus, 13

calligraphy, 21, 40
Calypso series, 19, *58–59*
Calypsos 2, 19, *58*
Calypsos 4, *59*
Candidium Blue, *116*
Cellini, Benvenuto, 13
Chadour (neckpiece), 21, *83*
Chadour series, 21, *83–85*
Chadour 6, 21, *84*
Chadour 9, 21, *84*
Chadour 17, 21, *85*
Chappelle, Jerry, 11, 12
checklist of the exhibition, 126–33
Chicago, 14–15
Chroma 3, *68*
College Art Gallery, SUNY New Paltz, *The Art of Enamels* (1973), 13–14
color, 17, 19, 21, 25, 31, 32, 34
Coloratura series, 19, *55*
Coloratura 3, 19, *55*
Composed Garden 1, *77*
Composed Garden 3, *78*
Composed Garden 6, *79*
Composed Garden 12, *80*
copper, 31–32, 33, 34
Coral Tesserae (neckpiece), 19, *51*
Coup de fleur, *109*
Cridler, Kim, 16
Crowley, Charles, 16
Cummins, Susan, 19

dance, 19
Danto, Arthur, 28, 32–33
 "Beauty and Morality," 28
Daunis-Dunning, Patricia, 15
Deerrun series, 19, *57*
Deerrun 2, 19, *57*
Deerrun 14, 19, *57*
Delta, Tesserae series (neckpiece), 19, *52*
Domestic Rescue, *114*

domestic subjects, 16, 26
Doty, Mark, 25–26, 28
 Still Life with Oysters and Lemons, 25
Douglas, Mary, 15
Drawing of mannequin, 17, *18*

Ebendorf, Robert, 11, 12, *12*, 13, 14, 16
electroformed copper, 19. 31–32, 33, 40
enamels, 13, 19, 21, 22, 31, 33, 34, 37
End of the Table, *105*

Fabergé, 13
Fairtree Gallery, New York, 14
Falino, Jeannine, 11
fashion industry, 17
Figure and Fragment, *36*, 37
Fike, Philip, 12
Florilegium (neckpiece), 21, *88*
Florilegium series, 21, *88–90*
Florilegium 1, 21, *89*
Florilegium 2, 21, *90*
Florilegium 3, 21, *90*
formalism, 30
Funk, Verne, 14

Gautama and Rose, *112*
gemstones, 19, 22
gold, 19, 34
Greek architecture, 32
Greenberg, Clement, 30, 31
Grippi, Jean, 11, 12
 garment patterns, 17, *18*

Hairy Who, 15
Harper, William, 13
Helwig, William, 13
Hersey, George, *The Lost Meaning of Classical Architecture: Speculations on Ornament from Vitruvius to Venturi*, 32
Hiroshige, Vincent, and Chrysanthemum, 16, *115*

Islamic culture, 20, 21, 32, 33, 34
Istanbul, 20, 34
Italy, 19

jewelry, 16, 17, 19, 20, 21, 22, 29, 30, 31, 33, 34, 37, 40, 41, 45–99
Jewelry USA, 19
Joselit, David "Notes on Surface: Toward a Genealogy of Flatness," 30
Junger, Herman, 13
Jurjani series, 21, 33, 73–76
Jurjani 4, 21, 33, 73
Jurjani 6, 21, 33, 74
Jurjani 7, 21, 33, 75
Jurjani 8, 21, 33, 76

Kington, Brent, 12

Lace and Light sketch, 22, 22
Lalique, 13
Landscape study (sketchbook), 37, 121
Le Soir Frieze, 117
Loos, Adolf, 33
 "Ornament and Crime," 29–30, 31
Lumen 1, 86
Lumen 4, 86

Making Hybrids 1, 108
Making Hybrids 2, 108
Matzdorf, Kurt, 13, 14, 16
McClelland, Tim, 16
Mediating Use, 113
Melancholia, 81
Melancholia wall relief, 24, 25, 33
Memphis Art Academy, 15
Metropolitan Museum of Art, New York, 13, 14
Mimlitsch Gray, Myra, 16–17
modernism, 29, 30, 31, 33, 34, 37
Morocco, 20
mosaics, 34
Mosaic Scenarios series, 21, 91–92, 94
Mosaic Scenarios 1, 21, 34, 91
Mosaic Scenarios 4, 21, 92
Mosaic Scenarios 5, 21, 92
Mosaic Scenarios 10, 21, 94

Moty, Eleanor, 13, 14
Museum of Contemporary Crafts, New York, 14

neckpieces, 19, 20, 41
New York City, 11, 13
New York University, 11
Nietzsche, Friedrich, 32
Noffke, Gary, 12
November Fragment, 54

Olson, Ace, 11, 12
ornamentation, 20–21, 22, 29, 30, 31–34, 37, 40

paintings and drawings, 16, 17, 22, 29, 31, 37–41, 111–25
Paley, Albert, 13
pattern, 17, 18, 20–21, 33
Pattern, Black Fragment series, 17, 30, 48
pattern decoration, 20–21
Pattern Fragment, Black Fragment series, 103
Pattern triptych, *White* series, 102
Penland School of Crafts, North Carolina, 13
Penn, Beverly, 16
Persian miniatures, 20, 20
Philadelphia, 11
Phillips, Patricia C., 25
Plant sketches and study for *Mosaic Scenarios* brooch, 37, 124
Polonaise 1, 95
Possibly Muzaffar Ali, *A Young Prince Holding Flowers*, 20, 20
Priori series, 19, 20, 22, 63–65
Priori 3, 19, 63
Priori 10, 19, 64
Priori 16, 19, 64
Priori 17, 19, 65
Priori 21, 19, 65

Raglan, White series (pendant), 30, 47
Red Site series, 17, 50
Red Site 1, 50
Red Site 2, 50

Red Site 3, 50
Red Steps, 16, 40, 107
Renaissance, 32
Renk, Merry, 13
Renwick Gallery, *Objects for Preparing Food* (1972), 14
representation, 26, 38
Rocaille series, 19, 20, 32, 69–71
Rocaille 6, 19, 32, 69
Rocaille 9, 19, 32, 69
Rocaille 12, 19, 32, 70
Rocaille 14, 19, 32, 71
rococo style, 32
Roman architecture, 32
Rosenfeld, Henry, 11
Rothman, Gerd, 13
Rousseau, Jean-Jacques, 28

Safavid series, 21, 87
Safavid 2, 21, 87
Sanford, Claire, 16
Schwarcz, June, 15
Seeler, Margarete, 13
Sentimental Signals, 114
Seppä, Heikki, 13
Shirt Pattern 3, White series (neckpiece), 30, 47
Silver Fleece, 46
Sketches of fold-over forms and folded paper, 38, 39
Society of North American Goldsmiths (SNAG), 12, 13, 14, 15
Spiral Tesserae, 104
Star-Eyed Brooch, 37, 82
State University of New York, New Paltz, 12–13, 14, 16–17
Steepy, Tracy, 16
still life, 25–26, 29, 40
Still Lifes Tabletops, 26, 27, 33
Studies for *Appalachian Spring*, 118
Studies for *Bottle and Body* series (sketchbook), 119
Study for figure and ground, 36, 37
Study for flowered wall decoration, 41, 123
Study for *Mosaic Scenarios* brooch, 37, 125
Study for *Rocaille* (sketchbook), 40, 120

Study for *Star-Eyed Brooch,* 37, *122*
Sturm, Dorothy, 15
Summervail Workshop for Art and Critical Studies, Colorado, 15
Syrian gold cup, 13, *14*

tesserae, 16, 41
Tesserae series, 19, *51–53*
Three Ravens and Red Barn, 112
Totem, Coloratura series, 19, *55*
Trilling, James, 33
Turkey, 20, 21, 34

Uffilia 5 (neckpiece), 66
University of Georgia, Athens, 11, 12
Urban Traces series, 22, *96–99*
Urban Traces 1, 22, *97*
Urban Traces 1 (neckpiece), 22, *96*
Urban Traces 2, 22, *97*
Urban Traces 4 (neckpiece), 22, *98*
Urban Traces 7, 22, *99*

Venturi, Robert, *Complexity and Contradiction in Architecture,* 29
Vigeland, Tone, 13

wall reliefs, 16, 29, 37, 41, *101–110*
White, Heather, 16
Whitehead, Joseph, 11
Willers, Karl Emil, 37
Woell, J. Fred, 15
Woodland Spectacle, 16, *110*

FIRST EDITION

Copyright © 2008 Fuller Craft Museum

All rights reserved under International and Pan-American Convention. Except for legitimate excerpts customary in review or scholarly publications, no part of this publication may be reproduced or transmitted in any form or by any means, electronic or mechanical, including photocopying, recording, or information storage or retrieval systems, without written permission from the publisher.

Published in the United States by Hudson Hills Press LLC, 3556 Main Street, Manchester, Vermont 05254.

Distributed in the United States, its territories and possessions, and Canada by National Book Network, Inc. Distributed outside of North America by Antique Collectors' Club, Ltd.

PRODUCTION CREDITS

Executive Director: Leslie Pell van Breen
Editorial Manager: Linda Bratton
Editor: Frances Bowles
Proofreader: Laura Addison
Indexer: Karla Knight
Production Manager: David Skolkin
Designer: Christopher Kuntze
Color separations by Pre Tech Color, Wilder, Vermont
Printed and bound by CS Graphics Pte., Ltd., Singapore
Founding Publisher: Paul Anbinder

LIBRARY OF CONGRESS CATALOGING-IN-PUBLICATION DATA

Falino, Jeannine
 Edge of the sublime : enamels by Jamie Bennett / by Jeannine Falino ; with essays by Patricia C. Phillips and Karl Emil Willers.
 p. cm.
 Issued in connection with an exhibition sponsored by Fuller Craft Museum, Brockton, Massachusetts.
 Includes bibliographical references and index.
 ISBN-13: 978-1-55595-284-6 (alk. paper)
 1. Bennett, Jamie, 1948—Exhibitions. 2. Enamel and enameling—United States—Exhibitions. I. Phillips, Patricia (Patricia C.) II. Willers, Karl Emil. III. Fuller Craft Museum. IV. Title.
 NK5008.B46A4 2008
 738.4092—dc22 2007037337

This publication celebrates the exhibition *Edge of the Sublime: Enamels by Jamie Bennett*, organized by Fuller Craft Museum, Brockton, Massachusetts, on view January–May 2008, then traveling to the following venues:

NATIONAL ORNAMENTAL METAL MUSEUM
Memphis, Tennessee, June–August 2008

SAMUEL DORSKY MUSEUM OF ART
New Paltz, New York, September–November 2008

ARKANSAS ARTS CENTER
Little Rock, Arkansas, December 2008–February 2009

RACINE ART MUSEUM
Racine, Wisconsin, March–August 2009

BELLEVUE ART MUSEUM
Bellevue, Washington, October 2009–February 2010

PHOTO CREDITS

All photographs by KEVIN SPRAGUE, except as noted below:
Courtesy of Jamie Bennett, figs. 1, 2
Photograph © 2008, Museum of Fine Arts, Boston, fig. 5
Dean Powell, plates 9, 10, 12, 13, 16, 18, 19, 35, 36, 38, 41, 42, 46, 47, 51, 52, 57, 58
Courtesy of the Museum of Fine Arts, Houston, plates 14, 32
John Lenz, plate 33
Courtesy of the Smithsonian American Art Museum, plate 37
Robert Hansen-Sturm, plates 40, 72, 74, 78–81, 83
Clic Photography, Racine, WI, plate 69
Jeannine Falino, plate 70
Bob Wagner, Samuel Dorsky Museum of Art, State University of New York, New Paltz, plate 71
Jim Fossett, plate 75
Richard Brouillet, plate 82
Nancy S. Schneider, page 134

Front cover: *Florilegium I*, 2000 (Cat. No. 74)
Back cover: *Urban Traces I* (neckpiece), 2005 (Cat. No. 86)

Fuller Craft Museum
455 Oak Street, Brockton, MA 02301
508.588.6000 www.fullercraft.org